PHILIP'S

BRITAIN
& IRELAND

NIGEL

STARGAZING 2024

MONTH-BY-MONTH GUIDE TO THE NIGHT SKY

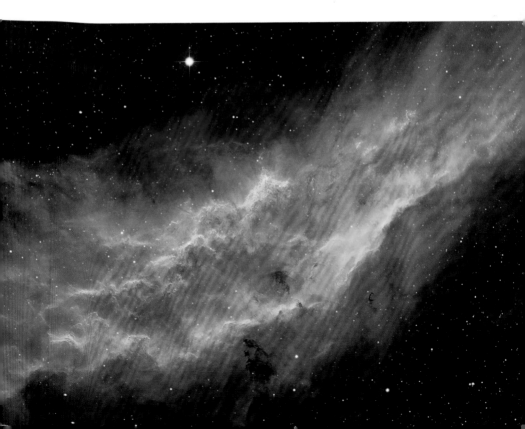

www.philips-maps.co.uk

Published in Great Britain in 2023 by Philip's,
a division of Octopus Publishing Group Limited
(www.octopusbooks.co.uk)
Carmelite House, 50 Victoria Embankment,
London EC4Y 0DZ
An Hachette UK Company (www.hachette.co.uk)

TEXT
Nigel Henbest © 2023 pp. 4–85, 90–95
Philip's © 2023 pp. 1–3
Robin Scagell © 2023 pp. 86–89

ARTWORKS © Philip's except pp. 13, 19, 25, 31, 37, 43, 49,
55, 61, 67, 73, 79 © Nigel Henbest/Philip's

ISBN 978-1-84907-651-7

Printed in China

Cover: Milky Way from the Callanish Standing Stones.
Title page: California Nebula.

MIX
Paper | Supporting
responsible forestry
FSC® C008047

Welcome to the latest edition of *Stargazing*! Within these pages, you'll find a complete guide to everything happening in the night sky throughout 2024 – whether you're a beginner or an experienced astronomer.

With the 12 monthly star charts, you can find your way around the sky on any night in the year. Impress your friends by identifying celestial sights ranging from the brightest planets to some pretty obscure constellations.

Every page of *Stargazing 2024* is bang up-to-date, bringing you everything that's new this year, from shooting stars to eclipses. And I'll start with a run-down of the most exciting sky sights on view in 2024 (opposite).

THE MONTHLY CHARTS

A reliable map is just as essential for exploring the heavens as it is for visiting a foreign country. So each monthly section starts with a circular **Star Chart** showing the whole evening sky.

To keep the maps uncluttered, I've plotted about 200 of the brighter stars (down to third magnitude), which means you can pick out the main star patterns – the constellations. (If the charts showed every star visible on a really dark night, there'd be around 3000 stars on each!) I also show the ecliptic: the apparent path of the Sun in the sky; it's closely followed by the Moon and planets as well.

You can use these charts throughout the UK and Ireland, along with most of Europe, North America and northern Asia – between 40 and 60 degrees north – though our detailed timings apply specifically to Britain and Ireland.

USING THE STAR CHARTS

It's pretty easy to use the charts. Start by working out your compass points. South is where the Sun is highest in the sky during the day; east is roughly where the Sun rises, and west where it sets. At night, you can find north by locating the Pole Star – Polaris – by using the stars of the Plough (see June's Constellation).

The left-hand chart then shows your view to the north. Most of the stars here are visible all year: these circumpolar constellations wheel around Polaris as the seasons progress. Your view to the south appears in the right-hand chart; it changes much more as the Earth orbits the Sun. Leo's prominent 'sickle' is high in the spring skies. Summer is dominated by bright Vega, Deneb and Altair. Autumn's familiar marker is the Square of Pegasus; while the stars of Orion rule the winter sky.

During the night, our perspective on the sky also alters as the Earth spins round, making the stars and planets appear to rise in the east and set in the west. The charts depict the sky in the late evening (the exact times are noted in the captions). As a rule of thumb, if you are observing two hours later, then the following month's map will be a better guide to the stars on view – though beware: the Moon and planets won't be in the right place.

THE PLANETS, MOON AND SPECIAL EVENTS

The charts also highlight the **planets** above the horizon in the late evening. I've

HIGHLIGHTS OF THE YEAR

- **Night of 3/4 January:** the Quadrantid meteor shower is at its best before the Moon rises at 1 am.
- **8 January, before dawn:** Venus and the crescent Moon form a striking duo in the south-east.
- **9 January, before dawn:** the thin crescent Moon lies near Venus and Mercury.
- **16 February:** the Moon occults some of the Pleiades.
- **Throughout March,** Comet Pons-Brooks is visible in binoculars, tracking from Andromeda to Aries and brightening from magnitude +7 to +5. It may also produce spectacular outbursts.
- **24 March:** Mercury at greatest separation from the Sun, marking its best evening appearance.
- **25 March, before dawn:** the Moon is slightly dimmed in a penumbral eclipse, setting during the eclipse as seen from Britain and Ireland.
- **8 April:** a total eclipse of the Sun is visible from parts of Mexico, the USA and Canada. Ireland and western Scotland experience a partial solar eclipse at sunset.
- **12 April:** Comet Pons-Brooks passes below Jupiter.
- **20 April:** Jupiter glides below Uranus, just 30 arcminutes away and 1500 times brighter.
- **21 April:** Comet Pons-Brooks reaches maximum brightness (magnitude +4.5).
- **Morning of 6 May:** it's an excellent year for observing the Eta Aquarid meteor shower.
- **15–16 July, early hours:** Mars passes little more than a Moon's width from Uranus.
- **Night of 12/13 August:** the Perseid meteor shower is spectacular after the Moon sets at 11 pm.
- **15 August, early hours:** Mars passes near Jupiter, only 20 arcminutes away and 20 times fainter.

- **21 August, early hours:** the Moon occults Saturn, with reappearance in the morning twilight.
- **21 August:** the Moon passes just 5 arcminutes below Neptune.
- **26 August, early hours:** the Last Quarter Moon occults some of the Pleiades stars including one of the bright Seven Sisters, Atlas.
- **8 September:** Saturn is opposite to the Sun, and nearest to the Earth.
- **Night of 8/9 September:** Mars passes below the star cluster M35.
- **18 September, early hours:** the first of three supermoons this year suffers a partial eclipse, visible from Europe, Africa and the Americas, with just 8 per cent of the Moon obscured.
- **20 September:** Neptune is opposite to the Sun, and nearest to the Earth.
- **28 September, before dawn:** Comet Tsuchinshan-ATLAS swings past the Sun.
- **2 October:** an annular eclipse of the Sun is visible from Rapa Nui (Easter Island) and the southern tip of South America, but not from Britain or Ireland.
- **13 October:** Comet Tsuchinshan-ATLAS is at its brightest as it passes closest to the Earth.
- **17 October:** the largest and brightest supermoon of 2024.
- **19 October:** the Moon occults some of the fainter Pleiades stars.
- **5 November:** the crescent Moon lies to the left of Venus in the dusk twilight.
- **17 November:** Uranus is at its closest to the Earth and opposite to the Sun in the sky.
- **6 December:** Jupiter is closest to the Earth.
- **7 December:** Jupiter lies opposite to the Sun in the sky.
- **Night of 17/18 December:** the Moon lies between Mars and Castor and Pollux; after dawn the Moon occults Mars in the daytime sky.

indicated the track of any **comets** known at the time of writing; though I can't guide you to a comet that's found after the book has been printed!

I've plotted the position of the Full Moon each month, and also the **Moon's position** at three-day intervals before and afterwards. If there's a **meteor** shower in the month, the charts show its radiant – the position from which the meteors stream outwards.

The **Calendar** provides a daily guide to the Moon's phases and other celestial happenings. I've detailed the most interesting in the **Special Events** section, including close pairings of the planets, times of the

equinoxes and solstices and – most exciting – **eclipses** of the Moon and Sun.

Check out the **Planet Watch** page for more about the other worlds of the Solar System, including their antics at times they're not on the main monthly charts. I've illustrated unusual planetary and lunar goings-on in the **Planet Event Charts**. There's a full guide to planetary motions, eclipses and meteor showers in **Solar System 2024** on pages 80–82.

MONTHLY OBJECTS, TOPICS AND PICTURES

Each monthly section highlights a fascinating **object** – a planet, a star or a nebula – and also a stunning **picture** taken by an amateur based in Britain or Ireland along with full technical information. And there's an in-depth exploration of an intriguing and often newsworthy **topic**, ranging from the Dark Ages of the Universe to the dark side of the Moon (spoiler alert: it doesn't exist ...)

GETTING IN DEEP

A practical **Observing Tip** is included each month, helping you to explore the sky with the naked eye, binoculars or a telescope.

Check out my guide to the **Top 20 Sky Sights**, including nebulae, star clusters and galaxies. You'll find it on pages 83–85.

And equipment expert Robin Scagell explains how to use narrowband filters to take stunning colour photos of nebulae in deep space. Specially tuned to pass only light from a nebula's gases, they also combat the astronomer's bane, light pollution.

The final section details the internationally approved dark-sky sites in Britain and Ireland, where you're guaranteed to be free of light pollution. It also includes a round-up of planetariums and public observatories you can visit, plus a guide to the best star parties and astronomical festivals.

Happy stargazing!

JARGON BUSTER

Have you ever wondered how astronomers describe the brightness of the stars or how far apart they appear in the sky? Not to mention how we can measure the distances to the stars? If so, you can quickly find yourself mired in some arcane astro-speak – magnitudes, arcminutes, light years and the like.

Here's a quick and easy guide to busting the astronomical jargon.

Magnitudes

It only takes a glance at the sky to see that some stars are pretty brilliant, while many more are dim. But how do we describe to other people how bright a star appears?

Around 2000 years ago, ancient Greek astronomers ranked the stars into six classes, or **magnitudes**, depending on their brightness. The most brilliant stars were first

magnitude, and the faintest stars you can see came in at sixth magnitude. So the stars of the Plough, for instance, are second magnitude while the individual Seven Sisters in the Pleiades are fourth magnitude.

Mars (magnitude –1.6 here) shines a hundred times brighter than the Seven Sisters in the Pleiades, which are around 5 magnitudes fainter.

Today, scientists can measure the light from the stars with amazing accuracy. (Mathematically speaking, a difference of five magnitudes represents a difference in brightness of one hundred times.) So the Pole Star is magnitude +2.0, while Rigel is magnitude +0.1. Because we've inherited the ancient ranking system, the brightest stars have the *smallest* magnitude. In fact, the most brilliant stars come in with a negative magnitude, including Sirius (magnitude –1.5).

And we can use the magnitude system to describe the brightness of other objects in the sky, such as stunning Venus, which can be almost as brilliant as magnitude –5. The Full Moon and the Sun have whopping negative magnitudes!

At the other end of the scale, stars, nebulae and galaxies with a magnitude fainter than +6.5 are too dim to be seen by the naked eye. Using ever larger telescopes – or by observing from above Earth's atmosphere – you can perceive fainter and fainter objects. The most distant galaxies visible to the Hubble Space Telescope are ten billion times fainter than the naked-eye limit.

Here's a guide to the magnitude of some interesting objects:

Sun	–26.7
Full Moon	–12.5
Venus (at its brightest)	–4.7
Sirius	–1.5
Betelgeuse (variable)	0.0 – +1.6
Polaris (Pole Star)	+2.0
Faintest star visible to the naked eye	+6.5
Faintest star visible to the Hubble Space Telescope	+31

Degrees of separation

Astronomers measure the distance between objects in the sky in **degrees** (symbol °): all around the horizon is 360°, while it's 90° from the horizon to the point directly overhead (the zenith).

As you can see in the photograph, it's possible use your hand – held at arm's length – to give a rough idea of angular distances in the sky.

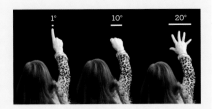

For objects that are very close together – like many double stars – we divide the degree into 60 arcminutes (symbol '). And for celestial objects that are extremely tiny – such as the discs of the planets – we split each arcminute into 60 arcseconds (symbol "). To give you an idea of how small these units are, it takes 3600 arcseconds to make up one degree.

Here are some typical separations and sizes in the sky:

Length of the Plough	25°
Width of Orion's Belt	3°
Diameter of the Moon	31'
Separation of Mizar and Alcor	12'
Diameter of Jupiter	45"
Separation of Albireo A and B	35"

How far's that star?

Everything we see in the heavens lies a long way off. We can give distances to the planets in millions of kilometres. But the stars are so distant that even the nearest, Proxima Centauri, lies some 40 million million kilometres away. To turn those distances into something more manageable, astronomers use a larger unit: one **light year** is the distance that light travels in a year.

One light year is about 9.46 million million kilometres. That makes Proxima Centauri a much more manageable 4.2 light years away from us. Here are the distances to some other familiar astronomical objects, in light years:

Sirius	8.6
Polaris	440
Centre of the Milky Way	26,700
Andromeda Galaxy	2.5 million
Most distant galaxies seen by James Webb Space Telescope	13.5 billion

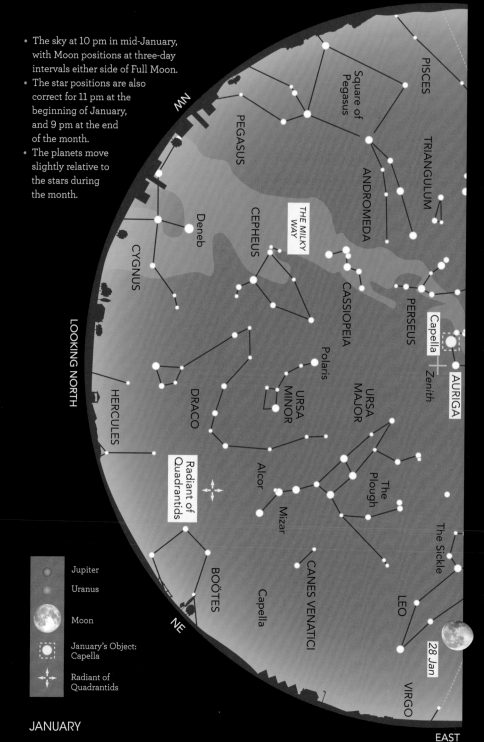

- The sky at 10 pm in mid-January, with Moon positions at three-day intervals either side of Full Moon.
- The star positions are also correct for 11 pm at the beginning of January, and 9 pm at the end of the month.
- The planets move slightly relative to the stars during the month.

WEST

LOOKING NORTH

NW

NE

EAST

PISCES

Square of Pegasus

PEGASUS

TRIANGULUM

ANDROMEDA

Deneb

CEPHEUS

THE MILKY WAY

CASSIOPEIA

PERSEUS

Capella

AURIGA

Zenith

CYGNUS

Polaris

URSA MINOR

URSA MAJOR

DRACO

HERCULES

Alcor

The Plough

Mizar

Radiant of Quadrantids

BOÖTES

Capella

CANES VENATICI

The Sickle

LEO

28 Jan

VIRGO

Jupiter

Uranus

Moon

January's Object: Capella

Radiant of Quadrantids

WEST

PISCES

TRIANGULUM

ARIES

16 Jan

Mira

CETUS

Jupiter

Uranus

19 Jan

PERSEUS

ERIDANUS

Pleiades

Hyades

TAURUS

El Nath

Crab Nebula

Aldebaran

ORION

Rigel

LEPUS

Capella

Zenith

zeta Tauri

AURIGA

22 Jan

Betelgeuse

Orion Nebula

COLUMBA

Castor

GEMINI

CANIS
MAJOR

Pollux

25 Jan

Sirius

URSA MAJOR

Procyon

THE MILKY
WAY

LEO

The Sickle

CANCER

CANIS MINOR

Regulus

PUPPIS

HYDRA

28 Jan

Ecliptic

VIRGO

SE

LOOKING SOUTH

TOP 20 SKY SIGHTS
(see pp. 83–85)

1 Orion Nebula

2 Betelgeuse

EAST

The new year opens with a tableau of dazzling stars: **Betelgeuse** and **Rigel** in **Orion,** escorted by glorious **Sirius** in **Canis Major** and – forming a giant arc above – **Procyon, Castor** and **Pollux, Capella** and the red giant **Aldebaran.** The long winter nights are bookended by the brilliant planets **Jupiter** (in the evening sky) and Venus before dawn.

JANUARY'S CONSTELLATION

Taurus (the Bull) is dominated by **Aldebaran,** the baleful eye of the celestial bovine, shining at magnitude +0.9. Although its hue is a distinct orange, Aldebaran is classified as a red giant star, a bloated and more elderly version of our Sun.

The 'head' of the bull is outlined by the **Hyades** star cluster, 153 light years away. Although Aldebaran looks to be part of this star grouping, it lies at less than half that distance. Even further off (440 light years) is the more spectacular **Pleiades** (or Seven Sisters) star cluster, packed with dazzling young stars.

Taurus has two 'horns': the star **El Nath** (Arabic for 'the butting one') to the north, and **zeta Tauri,** whose Babylonian name Shurnarkabti-sha-shutu – meaning 'star in the bull towards the

south' – is thankfully not used very much! Nearby, Chinese astronomers witnessed a brilliant supernova in 1054. The remains of this exploding star are visible today through a medium-sized telescope, as the still-glowing **Crab Nebula.**

JANUARY'S OBJECT

Capella, the Little She Goat, sails right overhead in our winter skies. Despite its name, this yellow star – the brightest in the constellation of **Auriga** (the Charioteer) – is anything but diminutive.

In fact, Capella consists of two giant stars, each about ten times wider than the Sun and shining 80 times brighter. In a tight gravitational embrace, these huge orbs complete one orbit around each other in just over three months. Further out, the system includes two faint red dwarf stars.

Capella is the sixth-brightest star in the night sky, and it currently lies 43 light years away. It was nearer in the past, and from 210,000 to 160,000 years ago its proximity made Capella the brightest night-time star; at magnitude –1.8, shining even brighter than Sirius today.

JANUARY'S TOPIC: A STAR'S LIFE

The stars seem to be constant and unchanging, but that's only because we're seeing a snapshot of their incredibly long lives, which can run into trillions of years. For a baby-picture, look

no further than the **Orion Nebula** (February's Picture). The fledgling stars there will grow up to become mature citizens of the **Milky Way**, like Sirius or our own Sun, shining as a result of nuclear reactions in their searingly hot cores.

As stars age – and their hydrogen fuel starts to run out – they develop the problems of middle age. Orange Aldebaran and baleful red **Betelgeuse** have swollen up and cooled down near the end of their lives. Some of these red giants eventually puff off their distended atmospheres into space as a planetary nebula, with a compact white dwarf star at its heart.

But the most massive red giants have a more spectacular demise, blowing themselves apart as supernovae that briefly shine billions of times brighter than the Sun. The Crab Nebula is the remnant of just such a stellar suicide. The core of a supernova is crushed down to become a tiny dense neutron star, or it may collapse completely to form a black hole.

JANUARY'S PICTURE

At first glance, this looks like one of those famous images taken by the Apollo astronauts, showing the Earth rising or setting behind the lunar terrain. But look again: it's not the Blue Planet, but the Red Planet.

The occasion was the **lunar occultation of Mars** on 8 December 2022, when the Full Moon moved right in front of Mars just as the planet was at opposition.

Pete Lawrence recorded a video of the Mars occultation using a high frame-rate camera (ZWO ASI174MM) attached to a Celestron C14 – a 356-mm Schmidt-Cassegrain telescope – working at f/28. In this video frame, the appearance of Mars has been enhanced by overlaying high-quality colour images that Pete took just before and after the occultation.

The Red Planet was only a few days past its closest point to Earth, and appeared larger than it had for two years. Astronomers across Europe and parts of North America eagerly turned their telescopes to view this rare event.

Observing from England, Pete Lawrence captured this striking image as the Moon crept up on the Red Planet. At this moment, four celestial objects were perfectly in line: the Sun, the Earth, the Moon and Mars.

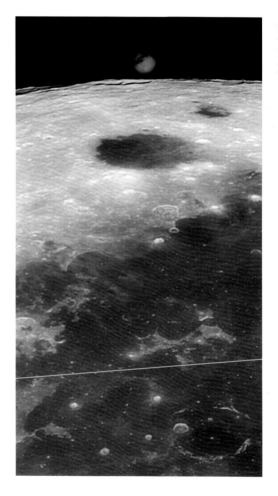

SUNDAY	MONDAY	TUESDAY	WEDNESDAY	THURSDAY	FRIDAY	SATURDAY
	1	2	3 Earth at perihelion; Quadrantids	4 3.30 am Last Quarter Moon; Quadrantids (am)	5 Moon near Spica (am)	6
7	8 Moon near Venus (am)	9 Moon between Venus and Mercury	10	11 11.57 am New Moon	12 Mercury W elongation	13
14 Moon near Saturn	15	16	17	18 3.53 am First Quarter Moon near Jupiter	19	20 Moon near Pleiades
21	22	23	24 Moon near Castor and Pollux	25 5.54 pm Full Moon	26	27 Moon near Regulus
28	29	30	31 Moon near Spica			

Quadrantid meteor shower

SPECIAL EVENTS

• **3 January, 0.39 am:** the Earth is at perihelion, its closest point to the Sun (147 million km away).

• **Night of 3/4 January:** maximum of the **Quadrantid meteor shower**, dust particles from the old comet 2003 EH₁ burning up in the Earth's atmosphere. You'll have good views of these bright colourful shooting stars until the Moon rises at 1 am.

• **8 January, before dawn:** Venus and the crescent Moon form a striking duo in the south-east (Chart 1a).

• **9 January, before dawn:** the thin crescent Moon lies between and below Venus and fainter Mercury (Chart 1a).

• **12 January, before dawn:** Mercury is at its greatest separation from the Sun in the morning sky (see Planet Watch).

• **14 January:** the Moon lies near Saturn.

• **18 January:** the brilliant 'star' near the Moon is Jupiter (Chart 1b).

1a 8–9 January, 7 am. Venus and Mercury with the crescent Moon.

1b 18 January, 10 pm. The Moon passes Jupiter.

- Magnificent **Jupiter** dominates the evening sky: at magnitude –2.5 it's far brighter than any of the stars and shines with a steady light. Lying at the borders of Aries, Pisces and Cetus, the giant planet sets around 1.45 am. The Moon is close by on 18 January (Chart 1b).

- **Saturn** lies to the lower right of Jupiter in Aquarius, shining 25 times more faintly at magnitude +1.0. The ringworld sets about 8 pm. The crescent Moon lies just to the left on 14 January.

- You'll need binoculars or a small telescope to spot **Neptune** (magnitude +7.8), on the border between Pisces and Aquarius. The most distant planet sets around 10 pm.

- Its near twin **Uranus** is just visible to the unaided eye (magnitude +5.7) in Aries, halfway between Jupiter and the Pleiades. It sets about 1 am.

- Just before dawn, **Venus** is resplendent in the south-east at magnitude –4.0. The Morning Star rises around 5.30 am. The crescent Moon lies to the right on 8 January (Chart 1a).

- Around the middle of January, look out for fainter **Mercury** to the lower left of Venus in the morning twilight. The narrow crescent Moon lies between Mercury and Venus on the morning of 9 January (Chart 1a). The innermost planet appears furthest from the Sun on 12 January, when it shines at magnitude –0.2 and rises about 5.20 am.

- **Mars** is lost in the Sun's glare this month.

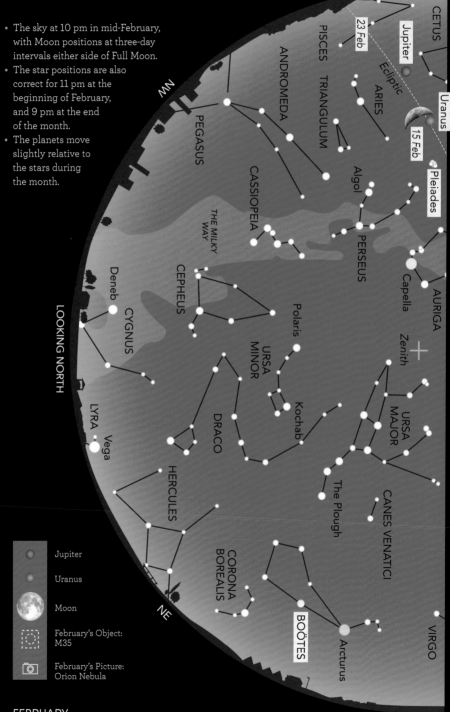

- The sky at 10 pm in mid-February, with Moon positions at three-day intervals either side of Full Moon.
- The star positions are also correct for 11 pm at the beginning of February, and 9 pm at the end of the month.
- The planets move slightly relative to the stars during the month.

WEST

CETUS

Jupiter

23 Feb

Ecliptic

Uranus

PISCES

ANDROMEDA

TRIANGULUM

ARIES

15 Feb

Pleiades

Algol

PERSEUS

Capella

AURIGA

PEGASUS

CASSIOPEIA

THE MILKY WAY

Zenith

Deneb

CEPHEUS

Polaris

URSA MAJOR

CYGNUS

URSA MINOR

Kochab

LYRA

Vega

DRACO

The Plough

CANES VENATICI

HERCULES

CORONA BOREALIS

BOÖTES

VIRGO

Arcturus

NW

NE

LOOKING NORTH

Jupiter

Uranus

Moon

February's Object: M35

February's Picture: Orion Nebula

EAST

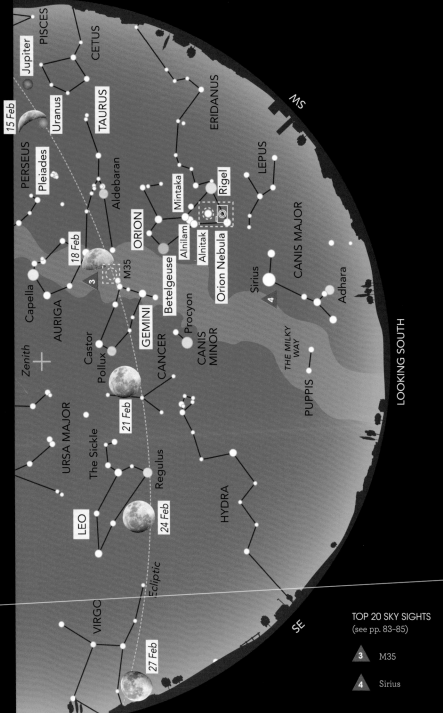

WEST

PISCES
Jupiter
CETUS
15 Feb
Uranus
TAURUS
PERSEUS
Pleiades
Aldebaran
ORION
18 Feb
Capella
AURIGA
Castor
Pollux
GEMINI
M35
3
Betelgeuse
Mintaka
Alnilam
Alnitak
Rigel
Orion Nebula
Procyon
CANCER
CANIS MINOR
21 Feb
Zenith
URSA MAJOR
The Sickle
Regulus
LEO
24 Feb
HYDRA
VIRGO
27 Feb
Ecliptic

ERIDANUS
LEPUS
Sirius
CANIS MAJOR
Adhara
4
THE MILKY WAY
PUPPIS

SW

LOOKING SOUTH

SE

EAST

FEBRUARY

TOP 20 SKY SIGHTS
(see pp. 83–85)

3 M35

4 Sirius

On February evenings, our sky is filled with more brilliant stars than we see in any other month. The glitzy winter constellations – centred on **Orion, Taurus** and **Gemini** – have drifted to the west since the beginning of January, because our perspective on the Universe constantly changes as the Earth orbits the Sun. Looking the other way, fresh constellations are rising in the east, led by **Leo** (the Lion) and **Boötes** (the Herdsman).

FEBRUARY'S CONSTELLATION

Striding high across the sky this month is the familiar figure of **Orion**. According to Greek myth, the formidable hunter was also the world's most handsome man. In the sky Orion also cuts a dash, with his seven major stars all placed in the 'Top 70' brightest stars in the sky.

Blood-red **Betelgeuse** marks one of his shoulders. This red giant is 760 times wider than the Sun, and one day it's destined to blow itself apart as a supernova. Orion's other brilliant star, **Rigel**, lies at the bottom of the hunter's tunic. In contrast to Betelgeuse, it's blue-white in colour, with a searingly hot temperature of 12,000°C.

Orion's belt is marked by well-matched **Alnitak, Alnilam** and **Mintaka**, lying over 1200 light years away. Despite this immense distance, they're prominent in our skies because each outshines our Sun 200,000 times over.

Look carefully below the Belt to spot a faint patch of light representing Orion's sword. This is the great **Orion Nebula**, a seething maelstrom of incandescent gas that's the birthplace of new stars created from a dark cloud of dust and gas (see Picture).

FEBRUARY'S OBJECT

Just visible to the unaided eye as it soars high on these winter nights, the star

cluster **M35** in **Gemini** is a gorgeous sight through binoculars or a small telescope. I can't do better than quote the words of the Victorian astronomer William Henry Smyth: 'From the small stars being inclined to form curves of three, four, and often with a large one at the root of the curve, it somewhat reminds one of the bursting of a sky-rocket.'

M35 was discovered by the Swiss astronomer Jean-Philippe Loys de Cheseaux around 1745, and included as the 35th entry in a famous catalogue of 'fuzzy objects' listed by the contemporary French astronomer Charles Messier.

This swarm of over 2000 stars lies 2800 light years away, towards the outer edge of the Milky Way Galaxy. M35 was born 150 million years ago, shortly before the more famous **Pleiades** star cluster in **Taurus**.

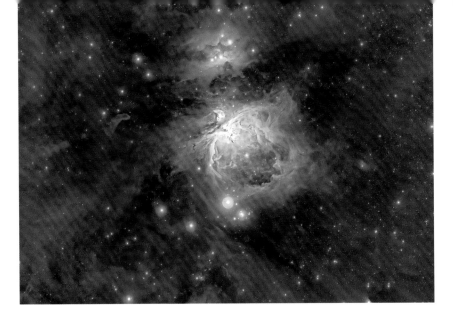

FEBRUARY'S TOPIC: LEAP YEAR

This year, February is blessed with an extra day – as anyone born on 29 February is all too aware! We have 'leap years' like 2024 because there aren't an exact number of days in a year: to be precise, a year is 365.2422 days long. If our calendars ran to 365 days every year, the dates would quickly get out sync with the seasons.

To solve this problem, in 46 BC Julius Caesar declared that every fourth year should have an extra day (added to poor February, as it's the shortest month). That makes an average of 365.25 days per year – which still isn't quite right. In 1582, Pope Gregory XIII amended the rules, so that a century year is a leap year only if you can divide it by 400. So 2000 was a leap year, while 2100 won't be. Over many centuries, the 'Gregorian calendar year' averages out to 365.2425 days.

That's pretty close to the actual length of the year. But, amazingly, a thousand years ago the Persian poet and astronomer

From Whittington, Shropshire, Pete Williamson captured this atmospheric shot of the Orion Nebula region on 15 December 2021 with a 106-mm Takahashi refractor at f/5. He took 17 × 300-second exposures though red, green and blue filters, and 10 × 200-second shots using a hydrogen alpha filter.

Omar Khayyam devised a calendar – still used today in Iran – that's even more accurate than our Gregorian calendar.

FEBRUARY'S PICTURE

The glowing **Orion Nebula** is visible to the unaided eye, just below the hunter's belt – and it's a glorious sight through binoculars or a small telescope. Some 1340 light years away and 24 light years across, the Orion Nebula is a hotbed of activity, energised by bright young stars. It's the nearest location to Earth where heavyweight stars are being born.

Pete Williamson's long-exposure image reveals that this bright gas cloud is just part of a huge star-forming complex. Around and behind the Orion Nebula lie dark clouds of dusty gas, poised to give birth to thousands more massive stars.

SUNDAY	MONDAY	TUESDAY	WEDNESDAY	THURSDAY	FRIDAY	SATURDAY
				1	2 1.18 pm Last Quarter Moon	3
4	5 Moon near Antares (am)	6	7 Moon near Venus (am)	8	9 10.59 pm New Moon	10
11	12	13	14 Moon near Jupiter	15 Moon near Jupiter	16 9.01 am First Quarter Moon occults the Pleiades	17
18	19	20 Moon near Castor and Pollux	21	22	23 Moon near Regulus	24 12.30 pm Full Moon
25	26	27	28 Moon near Spica	29		

The Pleiades

SPECIAL EVENTS

- **7 February, before dawn:** the narrowest crescent Moon lies to the right of Venus, low down in the twilight glow (Chart 2a). Binoculars will provide the best views.
- **14 February:** you'll find Jupiter to the upper left of the crescent Moon, at the borders of Aries, Pisces and Cetus.

- **15 February:** the bright object below the Moon is Jupiter.
- **16 February, 7–10 pm:** the Moon passes just below the centre of the Pleiades cluster, occulting some of its fainter outlying stars (Chart 2b). The most prominent star it hides, HD 23753 (magnitude +5.4), lies some 420 light years away.

2b 16 February, 8.30 pm. The Moon occults outlying Pleiades stars.

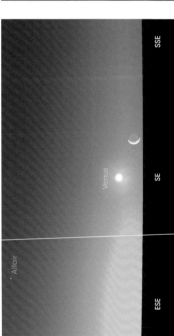

2a 7 February, 7 am. Venus with the crescent Moon.

• Lying in Aquarius, **Saturn** (magnitude +1.0) starts the month low in the west after sunset, setting at 7 pm. By mid-February, it has disappeared into the twilight glow.

• **Neptune** skulks in Pisces, at a dim magnitude +7.8. The outermost planet is setting about 8 pm, and by the end of the month it too has sunk from view.

• Blazing at magnitude –2.5 in Aries, **Jupiter** is

Jupiter

the undisputed king of the evening sky. The giant planet sets around midnight. You'll find the Moon nearby on 14 and 15 February.

• **Uranus** is next in the planetary line-up, appearing at the left side of Aries. At magnitude +5.9, the seventh planet is setting about 1 am.

• At the beginning of February, you can spot **Venus**

very low in the south-east before dawn, rising around 6 am. The Moon is close by on 7 February (Chart 2a). But by the end of the month, even the brilliant Morning Star has been overwhelmed by the glow of dawn.

• **Mercury** and **Mars** are too close to the Sun to be visible in February.

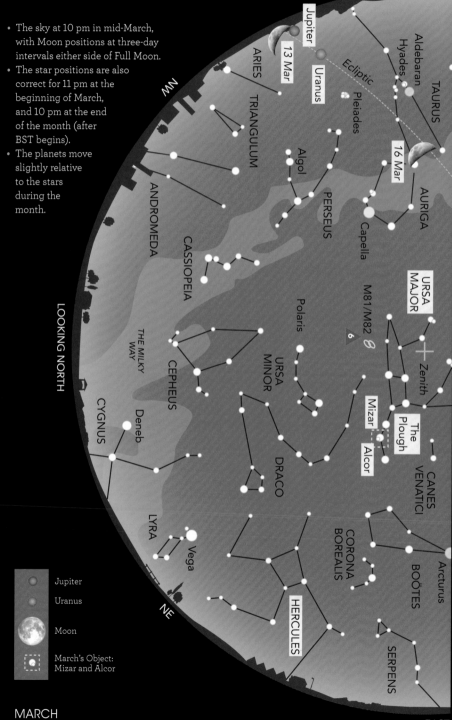

- The sky at 10 pm in mid-March, with Moon positions at three-day intervals either side of Full Moon.
- The star positions are also correct for 11 pm at the beginning of March, and 10 pm at the end of the month (after BST begins).
- The planets move slightly relative to the stars during the month.

WEST

NW

LOOKING NORTH

NE

EAST

Jupiter

13 Mar

Uranus

Ecliptic

Pleiades

Hyades

Aldebaran

TAURUS

ARIES

TRIANGULUM

Algol

16 Mar

AURIGA

PERSEUS

Capella

ANDROMEDA

CASSIOPEIA

URSA MAJOR

M81/M82

Polaris

THE MILKY WAY

CEPHEUS

URSA MINOR

Zenith

Mizar

The Plough

Alcor

CANES VENATICI

CYGNUS

Deneb

DRACO

LYRA

Vega

CORONA BOREALIS

BOÖTES

Arcturus

HERCULES

SERPENS

Jupiter

Uranus

Moon

March's Object: Mizar and Alcor

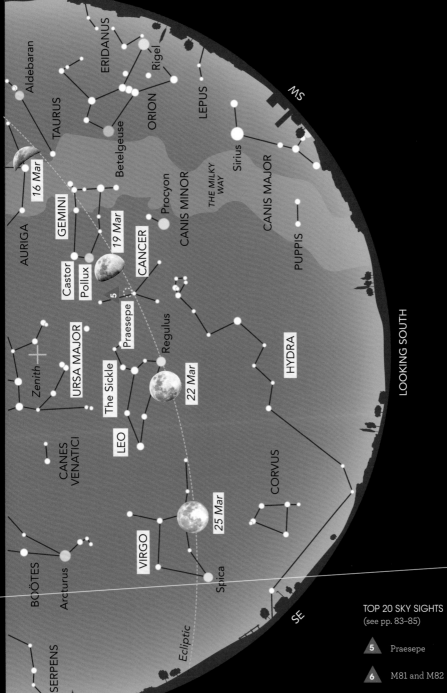

WEST

EAST

SW

LOOKING SOUTH

SE

Aldebaran
ERIDANUS
Rigel
ORION
Betelgeuse
TAURUS
LEPUS
Sirius
CANIS MAJOR
THE MILKY WAY
PUPPIS
Procyon
CANIS MINOR
16 Mar
AURIGA
GEMINI
19 Mar
Castor
Pollux
CANCER
Praesepe
5
Regulus
The Sickle
URSA MAJOR
Zenith
LEO
22 Mar
HYDRA
CANES VENATICI
CORVUS
VIRGO
25 Mar
BOÖTES
Arcturus
Spica
SERPENS
Ecliptic

TOP 20 SKY SIGHTS
(see pp. 83–85)

5 Praesepe

6 M81 and M82

MARCH **21**

It's a pretty disappointing month for planet lovers, with **Jupiter** the only shining beacon in our skies. Apart from dim **Uranus**, you won't see any other planets until late in the month, when Mercury makes its best evening appearance of the year. And check out the large spring constellations – **Leo**, **Virgo** and **Hydra** – now well on view in the southern sky. And you've a chance of catching a once-in-a-lifetime comet!

MARCH'S CONSTELLATION

Although it's well known as one of the constellations of the Zodiac – the band along which the Sun, Moon and planets appear to move – **Cancer** is easy to overlook, its stars so faint that city lights completely drown them out. Under dark skies, you can make out its spindly shape between the **Sickle** of **Leo** and the twin stars **Castor** and **Pollux** in **Gemini**.

In legend, Cancer attempted to nip **Hercules**'s foot during his altercation with the multi-headed monster **Hydra**. Alas for the crustacean, Hercules simply crushed it under his foot. But the goddess Juno took pity on the crab and placed it in the sky.

At the centre of the constellation lies a celestial gem, the star cluster **Praesepe**. Aptly nicknamed the 'Beehive Cluster', this swarm of a thousand stars 600 light years away is a magnificent sight through binoculars or a small telescope. Praesepe was well known to ancient Greek astronomers such as Ptolemy who called it 'a nebulous mass in the breast of the Crab'.

MARCH'S OBJECT

To spot the most famous pair of stars in the sky – **Mizar** (magnitude +2.0) and **Alcor** (magnitude +4.0) – home in on the 'kink' in the tail of **Ursa Major** (the Great Bear), which if you prefer is the handle of the **Plough**. Generations of astronomers have known this duo as 'the horse and rider'.

It's one of the few double stars you can resolve with the naked eye: most other star pairs are so close you need a telescope. But are Mizar and Alcor an item, or do they just happen to lie along the same line of sight? This subject has been a bone of contention between astronomers for decades. The most recent measurements, however, put them at very much the same distance – 82 light years for Alcor and 83 for Mizar – so they probably are in a gravitational embrace.

Even so, it's not a simple double star system. Mizar has a companion that's visible through a telescope, and both these stars are actually very close doubles, making four stars in all. And Alcor has a faint

OBSERVING TIP

This is the ideal time of year to tie down the main compass directions, as seen from your observing site. North is easy – just latch onto Polaris, the Pole Star, using the familiar stars of the Plough (see June's Constellation). And at noon, the Sun is always in the south. But the useful extra in March is that we hit the Spring Equinox, when the Sun rises due east, and sets due west. Memorise those positions relative to a tree or house around your horizon, and you'll know which way to orientate the Star Charts.

companion – so there's a total of six stars making up this amazing system.

MARCH'S TOPIC: EUDOXUS

Today, the ancient Greek colony of Knidos is a jumble of ruins on a Turkish peninsula where the Aegean Sea meets the Mediterranean. In its heyday, around 2400 years ago, it was the home of the pioneering astronomer Eudoxus, who studied in Italy, Sicily, Egypt and Athens before returning home.

Eudoxus was a formidable mathematician, but his heart lay in the stars. He was the first astronomer to try to explain why the planets follow convoluted paths across the sky, believing each planet was attached to a hollow transparent shell – or 'crystalline sphere' – that pivoted inside larger shells.

He also pulled together the star patterns that had been drawn up all over the ancient world. From Mesopotamia he took on board an Eagle and a Sea Goat,

Gary Palmer shot this superb view at the Ikarus Solar Observatory in Spain on 5 October 2022, using a 120-mm f/6.5 refractor (William Optics FLT 120), with a DayStar Quark Solar filter and a ZWO ASI 174M camera. He processed the image in PlanetarySystemStacker and Photoshop CC 2022.

while the early Elamite astronomers on the Persian Gulf contributed a Bull and a Lion. Closer at hand, Mediterranean sea-faring traditions supplied a Dragon and a Water Snake, while Greek myths added colourful characters – like Orion, Perseus and Cassiopeia – to the celestial tableau. With just a few minor changes and additions, it is Eudoxus's constellations that we still use today.

MARCH'S PICTURE

Imaged in close-up by Gary Palmer, the Sun's fiery surface is a maelstrom of activity. A **sunspot group** is the visible evidence of tangled magnetic fields, spilling out from the Sun's interior and reining in its brilliant roiling gases. Where the magnetism is strongest, it cools the Sun's surface to form dark sunspots.

The energy suppressed within the sunspots spills over into bright surrounding plages – from the French for 'beach'. Loops of magnetism arch upwards between the sunspots, confining dark filaments of gas silhouetted against the glowing solar surface: when seen at the edge of the Sun, the filaments appear as bright prominences. Solar activity is currently rising, and the rash of sunspots is expected to peak in 2025.

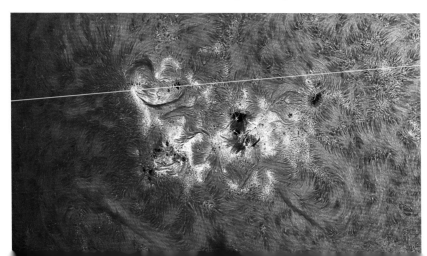

SUNDAY	MONDAY	TUESDAY	WEDNESDAY	THURSDAY	FRIDAY	SATURDAY
					1	2
3 3.24 pm Last Quarter Moon near Antares	4	5	6	7	8	9
10 9.00 am New Moon	11	12	13 Moon near Jupiter	14	15	16
17 4.11 am First Quarter Moon	18 Moon near Castor and Pollux	19 Moon near Castor and Pollux	20 Spring Equinox	21 Moon near Regulus	22	23
24 Mercury E elongation	25 7.00 am Full Moon: penumbral lunar eclipse	26 Moon near Spica	27	28	29	30
31 BST and IST begin (am)						

SPECIAL EVENTS

- **13 March:** the crescent Moon lies just to the right of Jupiter (Chart 3a).
- **20 March, 3.06 am:** the Spring Equinox, when day and night are equal.
- **24 March:** Mercury reaches its greatest separation from the Sun in the dusk twilight (see Planet Watch and Chart 3b).
- **25 March, 4.53–9.32 am:** the Moon is slightly dimmed by the outer part of the Earth's shadow in a penumbral eclipse, but it sets during the eclipse as seen from Britain and Ireland.
- **31 March, 1.00 am:** British Summer Time and Irish Standard Time start – put your clocks forward tonight.

- **Throughout March,** grab a pair of binoculars and scan low down in the evening twilight to seek out **Comet Pons-Brooks.** First seen in 1812, and named for co-discoverers Jean-Louis Pons and William Brooks, the comet travels around the Sun every 71 years and was last seen in 1954.

- This month, Comet Pons-Brooks tracks from Andromeda to Aries and is expected to brighten from magnitude +7 to +5. During past appearances, the comet has experienced spectacular outbursts when it's brightened by up to four magnitudes, so the celestial visitor may flare to become easily visible to the naked eye.

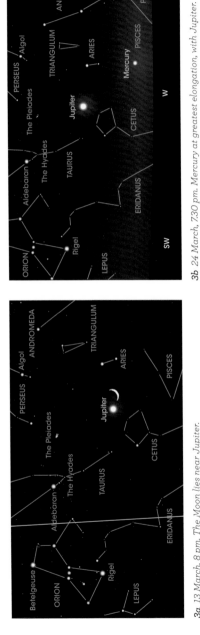

3a *13 March, 8 pm. The Moon lies near Jupiter.*

3b *24 March, 7.30 pm. Mercury at greatest elongation, with Jupiter.*

Mercury

- Giant planet **Jupiter** is resplendent in the early evening sky, its majesty enhanced by its location in a region of comparatively faint stars. At magnitude –2.1, the king of the planets resides in Aries and sets around 10.30 pm. The Moon passes Jupiter on 13 March (Chart 3a).
- Only just visible to the unaided eye at magnitude

+5.8, **Uranus** also lies in Aries, between Jupiter and the Pleiades. The seventh planet sets about 11 pm.

- Between 13 and 27 March, **Mercury** puts on its best evening show of 2024. You'll find the elusive planet low in the western evening twilight, below and to the right of Jupiter. Mercury starts this period at magnitude –1.2 and steadily fades to magnitude

+0.3. The innermost planet reaches its greatest

separation from the Sun on 24 March (Chart 3b).
- **Venus, Mars, Saturn** and **Neptune** are all lost in the Sun's glare this month.

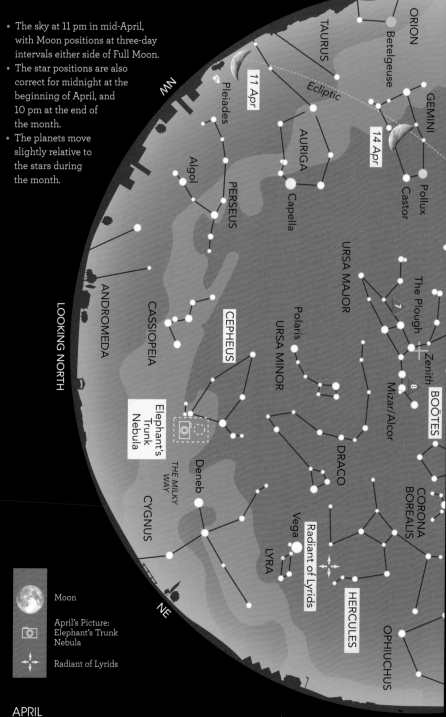

- The sky at 11 pm in mid-April, with Moon positions at three-day intervals either side of Full Moon.
- The star positions are also correct for midnight at the beginning of April, and 10 pm at the end of the month.
- The planets move slightly relative to the stars during the month.

WEST

LOOKING NORTH

NW

NE

EAST

ORION
Betelgeuse
TAURUS
Pleiades
11 Apr
Ecliptic
14 Apr
GEMINI
Castor
Pollux
AURIGA
Algol
Capella
PERSEUS
URSA MAJOR
The Plough
7
Zenith
Mizar/Alcor
8
BOÖTES
ANDROMEDA
CASSIOPEIA
CEPHEUS
Polaris
URSA MINOR
CORONA BOREALIS
Elephant's Trunk Nebula
THE MILKY WAY
DRACO
Deneb
CYGNUS
Vega
LYRA
Radiant of Lyrids
HERCULES
OPHIUCHUS

Moon

April's Picture: Elephant's Trunk Nebula

Radiant of Lyrids

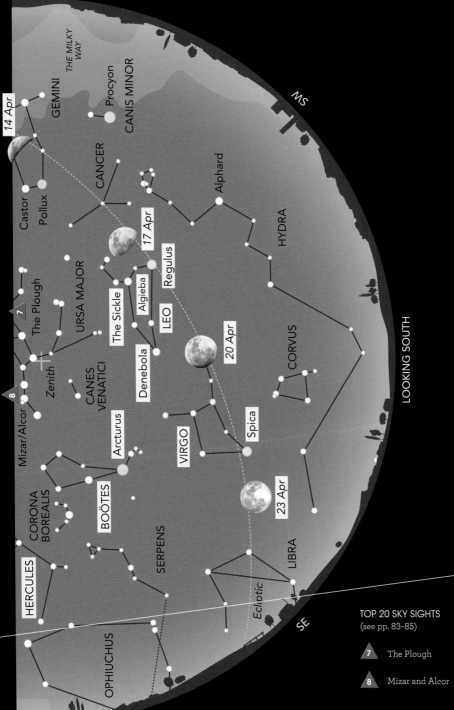

THE MILKY WAY

GEMINI

Procyon

CANIS MINOR

14 Apr

Castor

Pollux

CANCER

17 Apr

Algieba

Regulus

The Sickle

LEO

URSA MAJOR

The Plough

7

Denebola

Zenith

CANES VENATICI

Mizar/Alcor

8

Arcturus

BOÖTES

VIRGO

Spica

20 Apr

23 Apr

CORONA BOREALIS

HERCULES

SERPENS

OPHIUCHUS

LIBRA

Ecliptic

Alphard

HYDRA

CORVUS

LOOKING SOUTH

SW

SE

TOP 20 SKY SIGHTS
(see pp. 83–85)

7 The Plough

8 Mizar and Alcor

EAST

By the end of this month, we are planet-less, when Jupiter bows out after an eight-month stint dominating the evening sky. To compensate, three bright stars ride high in April: **Regulus** in **Leo**, with **Virgo**'s leading star **Spica** to the lower left, and orange **Arcturus** in **Boötes** lying above – not to mention Comet Pons-Brooks at its brightest in 71 years (see March's Special Events). Travel if you can to North America for a total eclipse of the Sun: it's visible as a partial eclipse from Ireland and western Scotland.

APRIL'S CONSTELLATION

Like the fabled hunter Orion, **Leo** is one of the rare constellations that resembles the real thing – in this case, a crouching lion. Leo commemorates a fearsome beast that **Hercules** slaughtered as the first of his 12 labours. The lion's fur couldn't be pierced by any weapon, so Hercules wrestled with the creature and choked it to death.

The lion's heart is marked by the first magnitude star **Regulus**. This celestial whirling dervish spins around in just 16 hours, making its equator bulge remarkably. Rising upwards is the **Sickle**, a back-to-front question mark that delineates the front quarters, neck and head of Leo. A small telescope shows that

Algieba, the star that makes up the lion's shoulder, is a beautiful close double star.

The other extremity of Leo is marked by **Denebola**, meaning 'the lion's tail' in Arabic. Just beneath the feline's tummy is a clutch of spiral galaxies; too faint to be seen with the unaided eye, you can track them down with a small telescope.

APRIL'S OBJECT

Astronomy is such a night-time subject it's easy to overlook the nearest and brightest star, our own **Sun**. Some 150 million kilometres from us, it's 267,000 times closer than Proxima Centauri. And it's the only star we can study in detail.

At its core, where temperatures reach 15.7 million °C, this giant ball of gas transmutes hydrogen into helium. Every second, the Sun devours 4 million tonnes of itself, converting matter into energy. This intense heat drives currents of incandescent gas up to the solar surface, where it cools and descends again – like boiling water in a pan.

The Sun's surface shines at 5500°C. But the thin atmosphere above – the corona – is far hotter, at over a million degrees. No-one knows why, but astronomers are hoping that the answer will come from two spacecraft flying dangerously close to the Sun, the Parker Solar Probe and Solar Orbiter.

OBSERVING TIP

Whether you're observing the partial phase of this month's solar eclipse, or just checking out our local star, NEVER look at the Sun directly with your unprotected eyes or – especially – with a telescope or binoculars: it could blind you permanently. For naked-eye observing, use special 'eclipse glasses' with dark filters (meeting the ISO 12312-2 safety standard). Or you can attach a sheet of a specialised metallised film (such as Baader AstroSolar® film) across the front of your instrument as a safe filter.

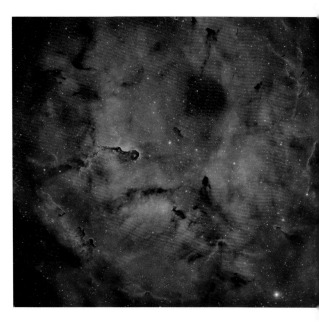

At the David Le Conte Astronomical Observatory in Guernsey in the Channel Islands, Jean Dean captured the Elephant's Trunk Nebula using a Takahashi FS-60C 60-mm refracting telescope and Starlight Xpress Trius 814 mono CCD, with narrowband filters passing light from hydrogen, sulphur and oxygen. The image comprises 73 × 20-minute exposures, which amounts to just over 24 hours of total observing time.

Powerful magnetic fields lace the Sun's surface and corona, creating dark sunspots and giant prominences reaching far into space. The magnetism is now approaching the peak of its 11-year cycle of magnetic activity, so we in for some tempestuous weather on our neighbourhood star.

APRIL'S TOPIC:
TOTAL SOLAR ECLIPSE

Pack your bags and book a transatlantic flight! On 8 April, the shadow of the Moon races across North America and people within this track will witness nature's greatest spectacle, a total eclipse of the Sun.

If you're after the maximum length of totality – 4 minutes 29 seconds – head for Mexico. That's also where the weather is likely to be best. The eclipse track then passes over Dallas (Texas), Indianapolis (Indiana), Cleveland (Ohio), Buffalo and Niagara Falls (New York), and Montreal (Quebec). Carbondale in Illinois is at a unique location: it also lay on the track of the 2017 total eclipse.

During the partial phase, make sure your eyes are protected (see Observing Tip). As the Sun disappears, you'll feel increasingly damp and cold, while the birds stop singing. At the moment of totality, look at the Sun directly, to witness its glowing corona – like a luminous flower with a dark heart – before totality ends in a brilliant diamond ring.

APRIL'S PICTURE

Seen against the glowing gases of the nebula IC 1396 is a long silhouette that's nicknamed – for obvious reasons – the **Elephant's Trunk Nebula**. It's a dense cloud of dust and gas that has survived when the surrounding material has been blasted away by the intense energy emitted by the central star in this view – in fact a close group of three stars that are all much heavier and hotter than the Sun.

The hollow at the end of the trunk in Jean Dean's photo is a small cavity that's been cleared by a pair of young stars. Infrared telescopes reveal infant stars still hidden in the dark depths of the elephant's trunk, which lies 2400 light years away in **Cepheus**.

SUNDAY	MONDAY	TUESDAY	WEDNESDAY	THURSDAY	FRIDAY	SATURDAY
	1	2 4.14 am Last Quarter Moon	3	4	5	6
7	8 7.20 pm New Moon: total solar eclipse	9	10 Moon near Jupiter	11	12 Comet Pons-Brooks passes below Jupiter	13
14	15 2.53 pm First Quarter Moon near Castor and Pollux	16	17	18 Moon near Regulus	19	20 Jupiter near Uranus
21 Comet Pons-Brooks at perihelion	22 Moon near Spica; Lyrids	23 7.00 am Full Moon; Lyrids (am)	24	25	26 Moon near Antares	27
28	29	30				

SPECIAL EVENTS

- **8 April:** a total eclipse of the Sun is visible from a narrow track across North America (see Topic). Most regions of North and Central America will witness a partial eclipse. If you are in Ireland or western regions of Scotland, you'll see a partial solar eclipse just before sunset (Chart 4a).

- **10 April:** there's a lovely sight in the early evening sky when the thin crescent Moon pairs up with the planet Jupiter.

- **12 April: Comet Pons-Brooks** passes below Jupiter. With binoculars, check out the comet, the giant planet, Uranus and the Pleiades all appearing in a vertical line (Chart 4b).

- **20 April:** Jupiter glides past Uranus (see Planet Watch).

- **21 April:** Comet Pons-Brooks reaches its maximum predicted brightness of magnitude +4.5 as it passes closest to the Sun. By the end of April, the comet disappears into the twilight glow.

- **Night of 22/23 April:** the maximum of the Lyrid **meteor shower** is ruined this year by the light of the Full Moon. These shooting stars appear to emanate from the constellation Lyra as debris from Comet Thatcher burns up in the Earth's atmosphere.

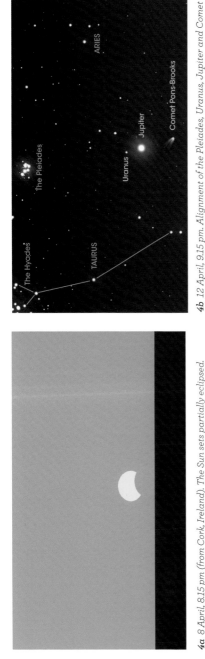

4a 8 April, 8.15 pm (from Cork, Ireland). The Sun sets partially eclipsed.

4b 12 April, 9.15 pm. Alignment of the Pleiades, Uranus, Jupiter and Comet Pons-Brooks.

- The bright 'star' in the west after sunset is the planet **Jupiter**, shining more brilliantly than anything in the night sky (bar the Moon) at magnitude –2.0. Lying in Aries, the giant of the Solar System is setting around 10 pm. The crescent Moon forms a stunning duo with Jupiter on 10 April.
- And grab binoculars or a small telescope to enjoy the spectacle of Jupiter's four biggest moons circling the planet from night to night: it's your last chance this year to view them in the evening sky, as the giant planet and its entourage disappear into the evening twilight by the end of April.
- Faint **Uranus** (magnitude +5.9) also lies in Aries and sets at around 10 pm. At the start of April, it's found to the upper left of Jupiter. But the giant planet is creeping upwards and passes to the left of Uranus on 20 April, just 30 arcminutes away and 1500 times brighter. Low in the dusk glow, whip out your binoculars or a small telescope to catch the conjunction. Uranus then sinks out of sight.
- **Mercury, Venus, Mars, Saturn** and **Neptune** are too close to the Sun to be seen in April.
- By the end of the month, we are in the unusual position of having no planets at all visible in the night sky, not even at dusk or before dawn.

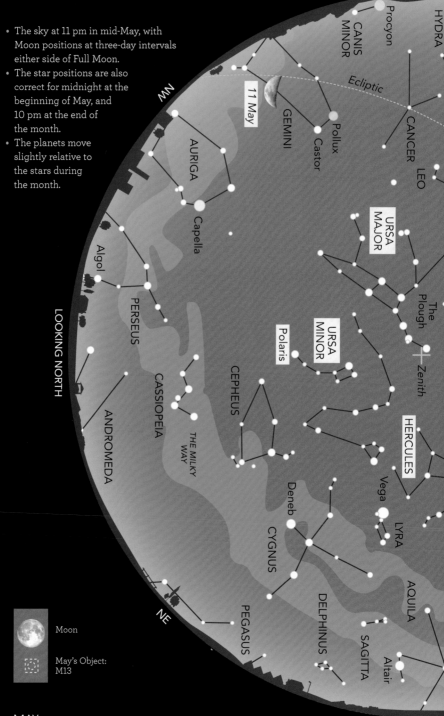

- The sky at 11 pm in mid-May, with Moon positions at three-day intervals either side of Full Moon.
- The star positions are also correct for midnight at the beginning of May, and 10 pm at the end of the month.
- The planets move slightly relative to the stars during the month.

WEST

HYDRA

CANIS MINOR

Procyon

Ecliptic

11 May

GEMINI

Pollux

Castor

CANCER

LEO

AURIGA

Capella

URSA MAJOR

The Plough

Zenith

Algol

PERSEUS

Polaris

URSA MINOR

HERCULES

CASSIOPEIA

CEPHEUS

Vega

LOOKING NORTH

ANDROMEDA

THE MILKY WAY

Deneb

LYRA

CYGNUS

AQUILA

NE

PEGASUS

DELPHINUS

SAGITTA

Altair

Moon

May's Object: M13

EAST

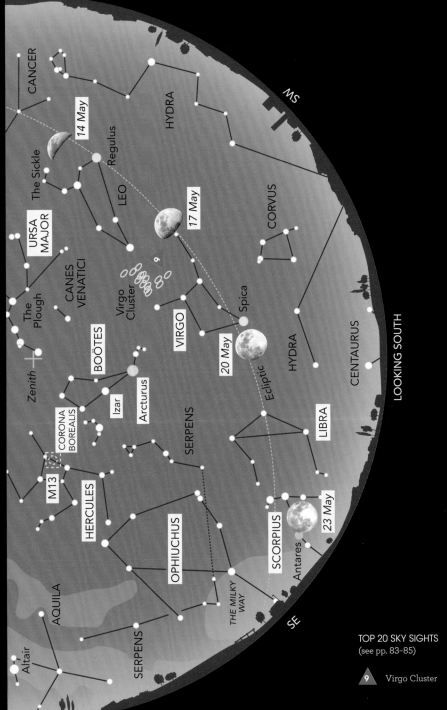

WEST

CANCER

14 May

The Sickle

Regulus

HYDRA

MS

URSA MAJOR

LEO

17 May

CORVUS

CANES VENATICI

The Plough

Virgo Cluster

9

Zenith

BOÖTES

VIRGO

Spica

Izar

Arcturus

20 May

Ecliptic

HYDRA

CENTAURUS

LOOKING SOUTH

CORONA BOREALIS

SERPENS

LIBRA

M13

HERCULES

OPHIUCHUS

SCORPIUS

23 May

AQUILA

THE MILKY WAY

Antares

SE

SERPENS

Altair

EAST

TOP 20 SKY SIGHTS
(see pp. 83–85)

9 Virgo Cluster

It's relatively quiet on the planetary front, so take the chance to explore the starry skies while the late evenings are still quite dark. Enjoy making the acquaintance of **Boötes**, with the little circlet of **Corona Borealis** to its left. **Scorpius, Libra** and **Virgo** lie to the south, while two faint sprawling giants – **Hercules** and **Ophiuchus** – fill the south-eastern sky.

MAY'S CONSTELLATION

Boötes, the Herdsman, is shaped rather like a kite. It was mentioned in Homer's *Odyssey*, and its name refers to the fact that Boötes seems to herd the stars that lie in the northern part of the sky as they circle the Pole Star, **Polaris**.

The name of its leading light, **Arcturus**, means 'bear-driver'. It apparently drives the two bears (**Ursa Major** and **Ursa Minor**) around the sky. Arcturus is the fourth-brightest star in the whole sky, and it's the most prominent star you can see on May evenings. A red giant star in its old age, Arcturus lies 37 light years from us, and shines 170 times more brilliantly than the Sun.

The star at the ten o'clock position from Arcturus is called **Izar**, meaning 'the belt'. Through a good telescope, it appears as a gorgeous double star – one star yellow and the other blue.

MAY'S OBJECT

At the darkest part of the night, you may spot a faint fuzzy patch way up high in the south-east, in the constellation **Hercules**. Through binoculars, it appears as a gently glowing ball of light. With a telescope, you can glimpse its true nature: a cluster of almost a million stars, swarming together in space.

This wonderful object is known as **M13**, because it was the 13th entry in the catalogue of 'fuzzy' objects recorded

by the 18th-century French astronomer Charles Messier. We now classify M13 as a 'globular cluster'. These great round balls of stars are among the oldest objects in our Milky Way Galaxy, dating back to its birth over 13 billion years ago.

In 1974, radio astronomers sent a message towards M13, hoping to inform the inhabitants of any planet there of our existence. There's only one problem: M13 lies so far away that we wouldn't receive a reply until AD 46,000.

MAY'S TOPIC:
VERA C. RUBIN OBSERVATORY

It's been called 'the most exciting telescope that no-one is talking about'! While the James Webb Space Telescope is rightly lauded for its stunning new images of the Cosmos, hardly anyone outside the astronomy world has heard of its

amazing ground-based sister, which will open its giant eye this year.

The Vera C. Rubin Observatory – named after one of the astronomers who discovered dark matter – is perched on a mountain peak in Chile. It contains a revolutionary telescope that provides an ultra-wide angle view of the sky, 40 times larger than the view through other large telescopes. It captures this view with the largest digital camera ever built.

With just one 15-second exposure, this telescope reveals asteroids, stars and galaxies down to magnitude +25: that's 30 million times fainter than you can see with the naked eye. Over the course of three nights, the Rubin Observatory images the entire sky visible from its location.

And that promises a treasure trove of new astronomical discoveries. The Rubin Observatory will map out the distribution of the dark matter and dark energy that control the expansion of the Universe. It will witness the collapse of stars to become black holes. And the telescope will track down almost all the asteroids in our region of the Solar System that may impact the Earth and maybe send us the way of the dinosaurs.

MAY'S PICTURE

The name of the **Homunculus Nebula** means 'little human being', and you can see the resemblance in Damian Peach's image. But in reality it's anything but 'little': this nebula measures a light year from head to toe, and contains as much matter as 40 Suns. It always lies below the horizon as seen from northern Europe, so Damian observed it remotely using a telescope in Chile.

The Homunculus Nebula is unique among known astronomical objects. It was blasted out into space by the central star in this photo, Eta Carinae, during an outburst that peaked in 1843 when this normally fifth-magnitude star briefly became the second-brightest star in our skies. Eta Carinae is one of the most massive stars in our Galaxy, and is destined to end its days as a supernova.

Damian Peach took this stunning image by remotely observing with a telescope in South America, at the Chilescope Observatory high in the Andes. The instrument was a 1-m f/8 Ritchey-Chretien reflector with a ZWO ASI174MM camera. It's a combination of thousands of images taken through red, green and blue filters.

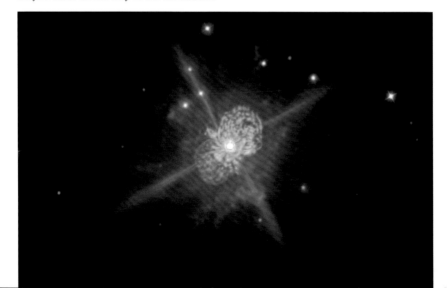

SUNDAY	MONDAY	TUESDAY	WEDNESDAY	THURSDAY	FRIDAY	SATURDAY
			1 12.27 pm Last Quarter Moon	2	3	4 Moon near Saturn (am)
5	6 Eta Aquarids (am)	7	8 4.22 am New Moon	9 Mercury W elongation	10	11
12 Moon near Castor and Pollux	13	14	15 12.48 pm First Quarter Moon near Regulus	16	17	18
19 Moon near Spica	20 Moon near Spica	21	22	23 2.53 pm Full Moon very near Antares	24 Moon very near Antares (am)	25
26	27	28	29	30 6.13 pm Last Quarter Moon	31 Moon near Saturn (am)	

SPECIAL EVENTS

- **4 May, before dawn:** the narrow crescent Moon lies to the lower left of Saturn in the morning twilight.
- **Morning of 6 May:** with the Moon well out of the way, it's an excellent year for observing the annual Eta Aquarid meteor shower

Full Moon

– tiny pieces of Halley's Comet burning up in Earth's atmosphere.

- **12 May:** the two stars near the Moon are Castor and Pollux.
- **Night of 23/24 May:** the Full Moon sails right under Antares in the wee small hours (Chart 5a).

- **31 May, before dawn:** you'll find Saturn to the left of the crescent Moon (Chart 5b) with equally bright Mars well to the left.

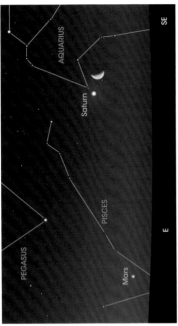

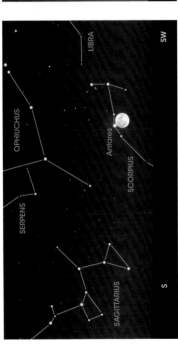

5a 24 May, 3.30 am. The Moon glides under Antares.

5b 31 May, 3.30 am. The Moon lies next to Saturn, with Mars well to the left.

Rings of Saturn

- After the planetary famine at the end of April, some of our neighbour worlds begin to appear before dawn this month, low in the twilight glow.
- First off the blocks is **Saturn**, rising around 3 am. The ringworld lies in Aquarius, at magnitude +1.1 and you'll find the slender crescent Moon nearby on the morning of 4 May and again on 31 May (Chart 5b).

- Next up is **Mars**. Also at magnitude +1.1, the Red Planet is in Pisces and appears above the horizon about 4 am.
- **Mercury** is lost in the Sun's glare throughout May – even though the innermost planet is at its greatest separation from the Sun on 9 May – as are **Venus, Jupiter, Uranus** and **Neptune**.

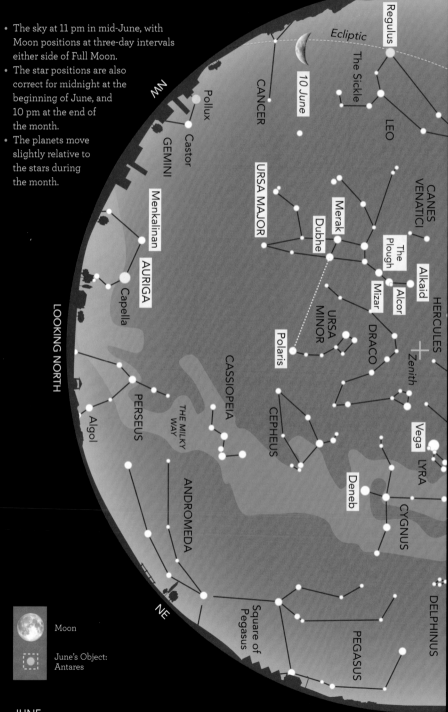

- The sky at 11 pm in mid-June, with Moon positions at three-day intervals either side of Full Moon.
- The star positions are also correct for midnight at the beginning of June, and 10 pm at the end of the month.
- The planets move slightly relative to the stars during the month.

WEST

Ecliptic

Regulus

The Sickle

10 June

CANCER

LEO

NNW

Pollux

Castor

GEMINI

Menkalinan

AURIGA

Capella

LOOKING NORTH

URSA MAJOR

Merak

Dubhe

The Plough

CANES VENATICI

Mizar

Alcor

Alkaid

HERCULES

DRACO

URSA MINOR

Polaris

Zenith

CASSIOPEIA

THE MILKY WAY

CEPHEUS

Vega

LYRA

PERSEUS

Algol

Deneb

CYGNUS

ANDROMEDA

NE

Square of Pegasus

PEGASUS

DELPHINUS

Moon

June's Object: Antares

EAST

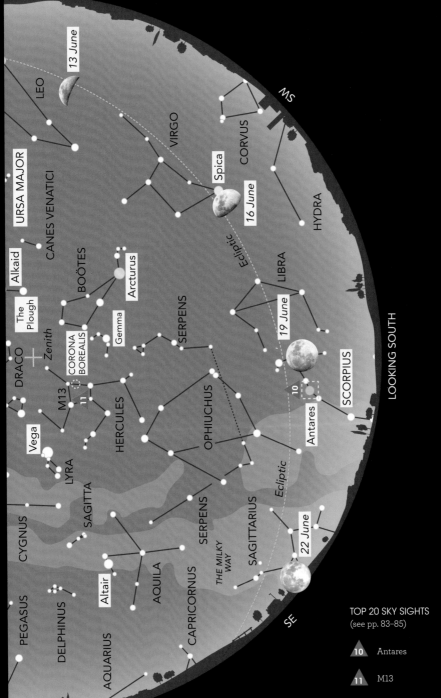

JUNE

13 June

LEO

URSA MAJOR

CANES VENATICI

VIRGO

MS

CORVUS

Spica

16 June

HYDRA

Alkaid

BOÖTES

Arcturus

The Plough

Zenith

Gemma

CORONA BOREALIS

SERPENS

LIBRA

19 June

DRACO

M13

11

HERCULES

OPHIUCHUS

SCORPIUS

Vega

10

LYRA

Antares

LOOKING SOUTH

SAGITTA

CYGNUS

SERPENS

Ecliptic

PEGASUS

AQUILA

SAGITTARIUS

22 June

Altair

THE MILKY WAY

CAPRICORNUS

Ecliptic

DELPHINUS

SE

AQUARIUS

TOP 20 SKY SIGHTS
(see pp. 83–85)

10 Antares

11 M13

Though the sky never quite grows dark this month – especially for the northern regions of Britain – take advantage of the warm nights to spot the brilliant stars that shine through the soft blue glow. Lovely orange **Arcturus** forms a giant triangle with blue-white **Spica** and **Regulus** to the south-west. It's matched in the east by the trio of **Vega, Deneb** and **Altair**, while red giant **Antares** lurks on the southern horizon.

JUNE'S CONSTELLATION

Ursa Major, the Great Bear, is an internationally favourite constellation. In Britain, its seven brightest stars are usually named the **Plough**, though children today often call it 'the saucepan'. In North America, it's known as the Big Dipper. Always on view in the northern hemisphere, the Plough is the first star pattern that most people get to know, especially as you can use its two end stars – **Merak** and **Dubhe** – to locate **Polaris**, the North Star.

Look closely at the star in the middle of the bear's tail (or the handle of the saucepan), and you'll see it's double. **Mizar** and its fainter companion **Alcor** comprise one of the few binary stars you can 'split' with unaided eye (see March's Object).

And – unlike most constellations – the majority of the stars in the Plough lie at the same distance and were born together. Leaving aside Dubhe and **Alkaid**, the others are all moving in the same direction, along with other stars of the Ursa Major Moving Group, which include **Menkalinan** in **Auriga** and **Gemma** in **Corona Borealis**. Over thousands of years, the shape of the Plough will gradually change, as Dubhe and Alkaid go off on their own paths.

JUNE'S OBJECT

The name **Antares** means 'the rival of Mars' – and it's easy to see why. Look low in the south to spot this ruby jewel marking the heart of the constellation **Scorpius** (the Scorpion). About 550 light years away, Antares is a bloated red giant star near the end of its life. Running low on its supplies of nuclear fuel, the star's core has shrunk while its outer layers have billowed out and cooled. Some 700 times wider than the Sun, Antares would engulf all the planets out to Mars if it lay at the centre of the Solar System. Eventually, the core of Antares will collapse and the star will explode as a brilliant supernova.

The red giant has a smaller companion (magnitude +5.5), which is hard to see against Antares's glare. Although it's a hot blue-white star, contrast with the ruddiness of Antares makes this companion one of the few stars that appear green.

OBSERVING TIP

Don't think that you need a telescope to bring the heavens closer. Binoculars are excellent – and you can fling them into the back of the car at the last minute. For astronomy, buy binoculars with large lenses coupled with a modest magnification. An ideal size is 7 × 50, meaning that the magnification is seven times, and that the diameter of the lenses is 50 millimetres.

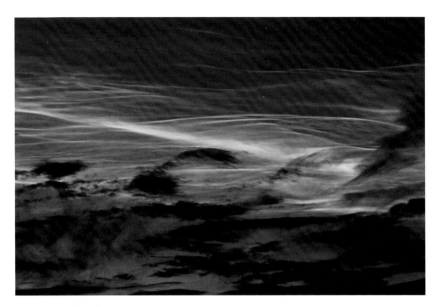

JUNE'S TOPIC:
'DARK SIDE OF THE MOON'

All too often media headlines ring with the phrase the 'dark side of the Moon', when they're talking about the region we can't see from the Earth. But here's the catch: there isn't a dark side of the Moon!

It's true that we only ever get to see one side of the Moon (the hemisphere that features the face of 'the man in the Moon'). The half that we can't see from Earth is known as the 'far side'. But the far side is not the 'dark side': as the Moon circles the Earth, *all* of its surface catches the Sun over the course of a month, and the far side is illuminated just as much as the 'near side'.

Our first view of the far side came in 1959, when Russia's Luna 3 took a peek. It revealed a densely cratered surface, with few of the huge lava-filled basins that we see on the near side. According to astronaut Bill Anders, flying the Apollo 8 spacecraft around the Moon in 1968, 'the

Stuart Atkinson snapped these undulating noctilucent clouds using a Canon 700D DSLR with an 80-300-mm lens. The exposure was 5 seconds at ISO 800, and he processed the image with FastStone Image Viewer.

back side looks like a sand pile my kids have played in ... it's all beat up, no definition, just a lot of bumps and holes'.

JUNE'S PICTURE

Look north in the late twilight at this time of year, and you may be lucky enough to see spookily bright clouds glowing blue-white against the dark sky – as Stuart Atkinson witnessed on 2 June 2022, during a nocturnal visit to Kendal Castle in Cumbria.

Aptly named from the Latin for 'night shining', these **noctilucent clouds** are most commonly seen in the summer from latitudes between 50° and 70°. Eighty kilometres high – right on the edge of space – these icy clouds are lit up by the Sun long after it's set.

SUNDAY	MONDAY	TUESDAY	WEDNESDAY	THURSDAY	FRIDAY	SATURDAY
30 ◐						1 ◐
2 ◑	3 ◐ ★ Moon near Mars (am)	4 ◐	5 ◐	6 ● 1.37 pm New Moon	7 ●	8 ● ★ Moon near Castor and Pollux
9 ◐	10 ◐	11 ◐ Moon near Regulus	12 ◐	13 ◑	14 ◑ 6.18 am First Quarter	15 ◑
16 ◐ ★ Moon very near Spica	17 ○	18 ○	19 ○	20 ○ Summer Solstice	21 ○	22 ○ 2.07 am Full Moon
23 ○	24 ○	25 ○	26 ○	27 ● Moon near Saturn (am)	28 ◑ 10.53 pm Last Quarter Moon near Saturn (am)	29 ◑

★ SPECIAL EVENTS

- **3 June, before dawn:** the crescent Moon forms a lovely duo with Mars, appearing low in the dawn twilight (Chart 6a).
- **8 June:** a thin crescent Moon lies to the left of Castor and Pollux, with brilliant Capella further to the right (Chart 6b).

- **16 June:** the Moon sails close to Spica.
- **20 June, 9.51 pm:** Summer Solstice. The Sun reaches its most northerly point in the sky, so today is Midsummer's Day, with the longest period of daylight and the shortest night. In the southern hemisphere, it's Midwinter's Day and nights are longest.

- **27 June, early hours:** Saturn lies to the left of the Moon. After they have set as seen from Britain and Ireland, the Moon occults Saturn – visible from eastern Australia and much of the Pacific.
- **28 June, early hours:** approaching its Last Quarter phase, the Moon is located to the left of Saturn.

Crescent Moon

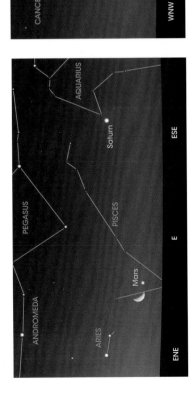

6a 3 June, 3.30 am. The Moon is near Mars, with Saturn to the right.

6b 8 June, 10.30 pm. The Moon next to Castor and Pollux.

• All the planetary action this month is in the morning sky. **Saturn** rises around 1 am, shining at magnitude +1.0 in Aquarius. The Moon is near the ringed planet on the mornings of 27 and 28 June.

• **Neptune** (magnitude +7.8) lies in Pisces and rises about 1.30 am.

• About 2.30 am, **Mars** appears above the eastern horizon. At magnitude +1.1, the Red Planet is roughly the same brightness as Saturn, but more difficult to see because it's lower in the dawn twilight. The narrow crescent Moon lies to the left of Mars on the morning of 3 June – binoculars will give you the best view (Chart 6a). During the month, Mars moves from Pisces into Aries.

• From the middle of June onwards, you'll find brilliant **Jupiter** (magnitude –2.0) low in the north-east just before sunrise. The giant planet rises around 3.30 am, and lies in Taurus.

Mars

• During the last few days of June you may catch **Mercury** very low in the north-west after sunset (best seen in binoculars). The innermost planet shines at magnitude –0.7 and sets at 10.30 pm.

• **Venus** and **Uranus** are too close to the Sun to be visible this month.

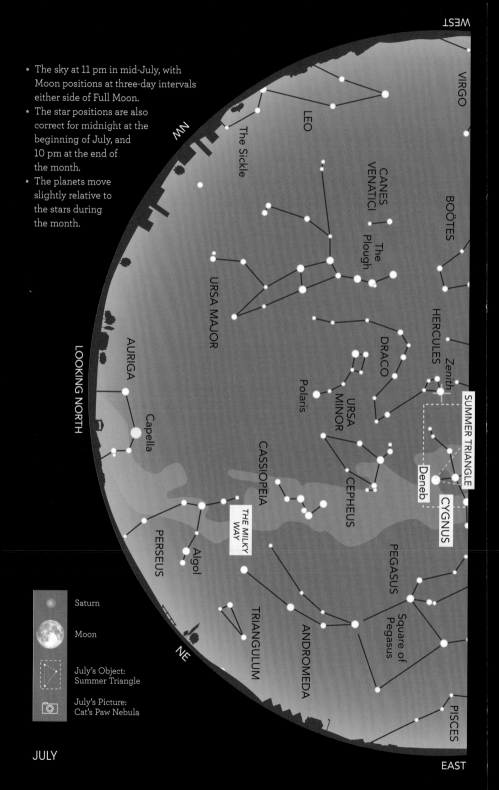

- The sky at 11 pm in mid-July, with Moon positions at three-day intervals either side of Full Moon.
- The star positions are also correct for midnight at the beginning of July, and 10 pm at the end of the month.
- The planets move slightly relative to the stars during the month.

WEST

VIRGO

NW

LEO

The Sickle

CANES VENATICI

BOÖTES

The Plough

URSA MAJOR

HERCULES

Zenith

DRACO

SUMMER TRIANGLE

AURIGA

Polaris

URSA MINOR

Capella

LOOKING NORTH

CASSIOPEIA

CEPHEUS

Deneb

CYGNUS

THE MILKY WAY

PEGASUS

PERSEUS

Algol

Square of Pegasus

TRIANGULUM

ANDROMEDA

NE

Saturn

Moon

July's Object: Summer Triangle

July's Picture: Cat's Paw Nebula

PISCES

JULY

EAST

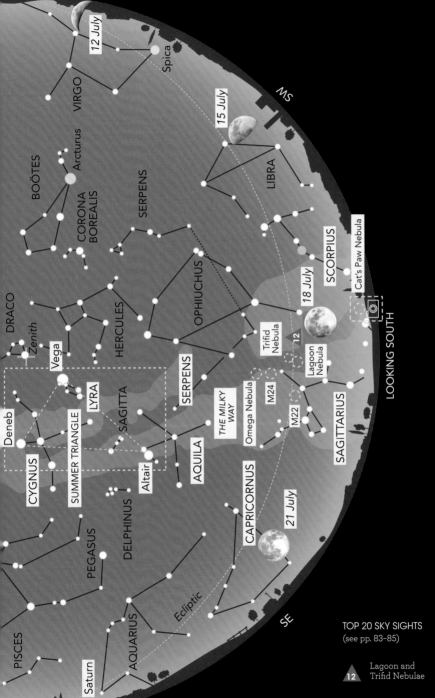

WEST

JULY

12 July

Spica

VIRGO

BOÖTES

Arcturus

CORONA
BOREALIS

SERPENS

15 July

SW

LIBRA

SCORPIUS

Cat's Paw Nebula

18 July

DRACO

Zenith

Vega

HERCULES

OPHIUCHUS

12

Trifid
Nebula

Lagoon
Nebula

LOOKING SOUTH

LYRA

SERPENS

THE MILKY
WAY

Omega Nebula

M24

M22

SAGITTARIUS

SUMMER TRIANGLE

SAGITTA

Deneb

CYGNUS

AQUILA

Altair

CAPRICORNUS

21 July

DELPHINUS

PEGASUS

Ecliptic

PISCES

AQUARIUS

Saturn

SE

EAST

TOP 20 SKY SIGHTS
(see pp. 83–85)

12 Lagoon and
 Trifid Nebulae

Two of the most ancient constellations, **Sagittarius** and **Scorpius**, are at their best this month, decorating the southern region of the sky. These star patterns lie in front of the brightest parts of the **Milky Way**, towards the heart of our Galaxy, and are packed full with nebulae and star clusters.

JULY'S CONSTELLATION

To the ancient Greeks, the star pattern **Sagittarius** represented an archer, with the torso of a man and the body of a horse, though to modern eyes the shape suggests merely a teapot.

Sagittarius is rich in nebulae and star clusters, easily visible in binoculars. Above the spout lies the wonderful **Lagoon Nebula** – a region of starbirth that's visible to the naked eye on a really dark night. Its neighbour, the three-lobed **Trifid Nebula**, requires a telescope.

Between Sagittarius and **Aquila**, you'll find a bright patch of stars in the Milky Way, catalogued as **M24**. Raise your binoculars higher to spot another star-forming region, the **Omega Nebula**. Finally, the fuzzy patch **M22** is a globular cluster of almost a million stars, lying 11,000 light years away.

JULY'S OBJECT

The **Summer Triangle** is very much part of this season's skies (and it hangs around for most of the autumn, too). Its corners are marked by the brightest stars in the constellations of Aquila (the Eagle), **Lyra** (the Lyre) and **Cygnus** (the Swan).

These three stars look about the same brightness, but they're very different beasts. Aquila's principal star, **Altair** – its name means 'flying eagle' – is one of the Sun's nearest neighbours, just

17 light years away, and it spins around at a breakneck rate of one rotation every 9 hours.

Vega, in Lyra, lies just over 25 light years away. It's a young white star nearly twice as hot as the Sun, and it's surrounded by a dusty disc, probably the debris from asteroids or comets colliding.

Deneb means 'tail' – of the swan, Cygnus – and in our skies it's the faintest of the trio. But the reality is different. Lying 2600 light years away, Deneb shines as brilliantly as 200,000 Suns.

JULY'S TOPIC: PULSARS

It was a signal so weird that the discoverers labelled it 'LGM-1'; perhaps the first communication from 'Little Green Men'. The radio astronomers at Cambridge, in 1967, had detected a regular stream of radio pulses, once every 1.337 seconds. It wasn't coming from an alien

intelligence, however, but something almost as outlandish: a pulsar.

A pulsar is the collapsed core of a massive star that has exploded as a supernova. It's composed entirely of tiny subatomic particles called neutrons, so tightly packed that a pulsar (also called a neutron star) contains as much matter as the Sun, in a ball no bigger than London!

A pinhead of its material would weigh as much as a fully laden supertanker, and its gravity is so strong you'd expend more effort climbing a 1-centimetre bump than in ascending Mount Everest on Earth. A typical pulsar has a fearsome magnetic field too, a thousand billion times stronger than Earth's magnetism. As it spins round, beams of radiation sweep around like a lighthouse beacon, creating its tell-tale radio pulses.

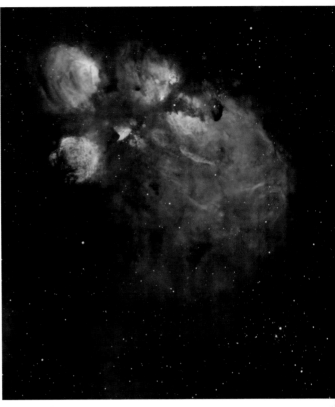

Peter Jenkins took this image remotely using instruments at Telescope Live's El Sauce Observatory in the Rio Hurtado Valley, Chile. The telescope was a 500-mm Newtonian reflector with a FLI PL16803 camera. Peter took 4 × 600-second exposures through hydrogen alpha and oxygen filters, and 3 × 600-second exposures in sulphur – just under 2 hours of exposures in total.

JULY'S PICTURE

Graphically known as the **Cat's Paw Nebula**, NGC 6334 would be the foot of a truly immense cosmic beast: this extremity alone is 50 light years across. Lying 5500 light years away in the 'sting' of **Scorpius** (the Scorpion), the nebula was first spotted by John Herschel from Cape Town, South Africa, where the Cat's Paw passes overhead. From the UK, Peter Jenkins made this observation remotely with a telescope in Chile.

Each of the 'pads' in the nebula is a giant bubble of hot gas energised by young massive stars. Within the surrounding dark clouds, thousands more stars are being born right now. The Cat's Paw is one of the most frenetic star-formation regions in our Galaxy, spawning new stars at four times the rate of the more famous Orion Nebula.

SUNDAY	MONDAY	TUESDAY	WEDNESDAY	THURSDAY	FRIDAY	SATURDAY
	1 Moon near Mars (am)	2	3 Moon near Jupiter and the Pleiades (am)	4	5 11.57 pm New Moon	6 Earth at aphelion
7 Moon near Mercury	8	9 Moon near Regulus	10	11	12	13 11.48 pm First Quarter Moon near Spica
14	15 Mars near Uranus (am)	16 Mars near Uranus (am)	17 Moon near Antares	18	19	20
21 11.17 am Full Moon	22 Mercury E elongation	23	24 Moon near Saturn	25	26	27
28 3.51 am Last Quarter Moon	29	30 Moon near Mars and the Pleiades (am)	31 Moon near Jupiter			

SPECIAL EVENTS

- **3 July, before dawn:** there's a lovely sight low in the north-east as the sky brightens, with the crescent Moon appearing directly above Jupiter and the Pleiades to the upper right.
- **6 July, 6.06 am:** the Earth is furthest from the Sun (aphelion), at 152 million km.
- **7 July:** Mercury lies immediately below the crescent Moon, very low in the evening twilight (best seen in binoculars).
- **15–16 July, early hours:** Mars passes little more than a Moon's width from Uranus (see Planet Watch and Chart 7a).
- **30 July, before dawn:** look out for a beautiful tableau in the morning sky, with the crescent Moon next to the Pleiades, while Mars, Aldebaran and Jupiter form a triangle to the lower left (Chart 7b).
- **31 July, before dawn:** another striking sight in the dawn sky as Jupiter lies to the lower right of the narrow crescent Moon, at the apex of a triangle with fainter Mars and Aldebaran (Chart 7b).

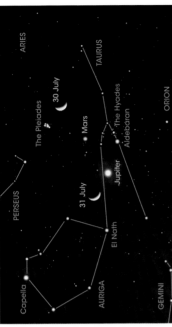

7b 30-31 July, 3 am. The Moon with the Pleiades, Mars, Jupiter and Aldebaran.

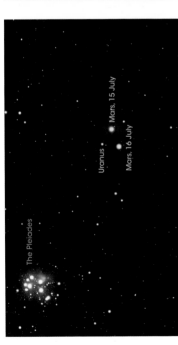

7a 15-16 July, 2 am. Mars passes under Uranus.

• Grab a pair of binoculars and scan the north-western horizon at dusk to catch elusive **Mercury**; on 7 July, it forms a striking pair with the narrow crescent Moon. The best views of Mercury come early in the month, when it's brightest (magnitude −0.5); by the time of greatest separation from the Sun on 22 July it has faded to magnitude +0.5.

• Rising about 11 pm, **Saturn** lies in Aquarius and shines at magnitude +0.8. The Moon is to the left of Saturn on 24 July.

• In neighbouring Pisces, **Neptune** glows at a mere magnitude +7.7 and rises around 11.30 am.

• **Mars** travels from Aries into Taurus during July. It's slightly fainter than Saturn, at magnitude +1.1, and rises about 1 am. The crescent Moon is near the Red Planet on the mornings of 1 and 2 July. On the mornings of 15 and 16 July, Mars passes near Uranus (see right), and at the end of July it's closing in on Jupiter, with Aldebaran below.

• **Uranus** lies in Taurus, rising around 1 am, and just visible to the unaided eye at magnitude +5.8. Mars acts as a convenient guide to finding Uranus in the early hours of 15 and 16 July: Uranus lies just 40 arcminutes above the Red Planet and is 80 times fainter (you'll find it most easily with binoculars). Using a telescope to bring out their colours, contrast the reddest planet with the greenest world in the Solar System (Chart 7a).

• Blazing at magnitude −2.1, **Jupiter** is also in Taurus and rises about 1.30 am. As the Moon sails over the giant planet on the mornings of 3, 30 and 31 July we're treated to some gorgeous groupings of Jupiter and the crescent Moon with the Pleiades, Aldebaran and Mars (Chart 7b).

• **Venus** is lost in the Sun's glare in July.

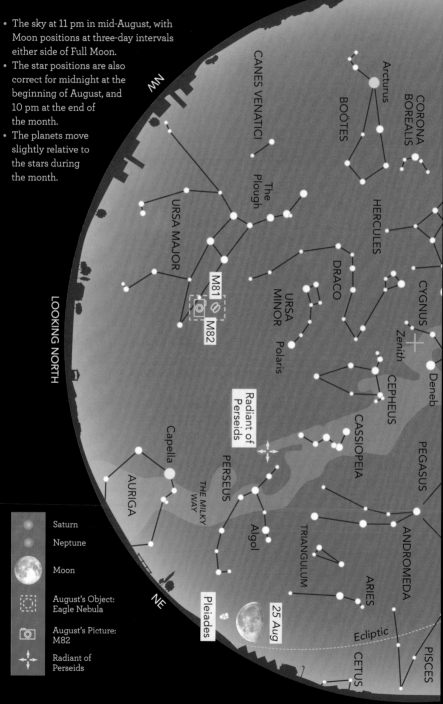

- The sky at 11 pm in mid-August, with Moon positions at three-day intervals either side of Full Moon.
- The star positions are also correct for midnight at the beginning of August, and 10 pm at the end of the month.
- The planets move slightly relative to the stars during the month.

WEST

NW

CANES VENATICI

Arcturus

BOÖTES

CORONA BOREALIS

The Plough

URSA MAJOR

HERCULES

DRACO

URSA MINOR

Polaris

CYGNUS

Zenith

Deneb

CEPHEUS

LOOKING NORTH

Radiant of Perseids

CASSIOPEIA

PEGASUS

Capella

AURIGA

PERSEUS

THE MILKY WAY

Algol

TRIANGULUM

ANDROMEDA

ARIES

NE

Pleiades

25 Aug

Ecliptic

CETUS

PISCES

EAST

Saturn

Neptune

Moon

August's Object: Eagle Nebula

August's Picture: M82

Radiant of Perseids

M81

M82

AUGUST

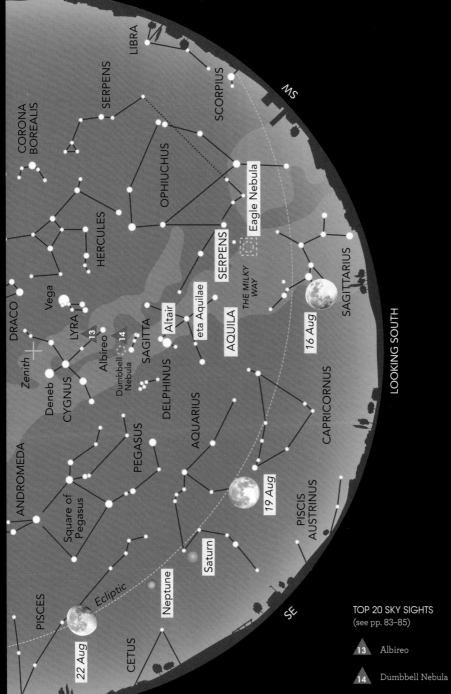

WEST

SW

LIBRA

SERPENS

CORONA
BOREALIS

SCORPIUS

DRACO

OPHIUCHUS

Eagle Nebula

HERCULES

SERPENS

Vega

THE MILKY
WAY

SAGITTARIUS

LYRA

13

eta Aquilae

Zenith

Albireo

14

Altair

AQUILA

16 Aug

SAGITTA

Deneb

CYGNUS

Dumbbell
Nebula

DELPHINUS

LOOKING SOUTH

ANDROMEDA

PEGASUS

AQUARIUS

CAPRICORNUS

Square of
Pegasus

19 Aug

PISCIS
AUSTRINUS

Saturn

SE

PISCES

Ecliptic

Neptune

22 Aug

CETUS

TOP 20 SKY SIGHTS
(see pp. 83–85)

13 Albireo

14 Dumbbell Nebula

EAST

It's a month of lunar and planetary shenanigans, though unfortunately most of the action takes place in the wee small hours. First Mars has a close encounter with Jupiter, then the Moon hides **Saturn**, skims past **Neptune** and occults some of the **Pleiades**. Also, we're treated to a great display of the **Perseid** meteors.

AUGUST'S CONSTELLATION

Soaring over the summer landscape, **Aquila** (the Eagle) is named after the bird that was a companion to the god Jupiter. The pet eagle carried the mighty god's thunderbolts, and scooped up the Trojan youth Ganymede when Jupiter took a shine to the handsome youth.

The constellation is dominated by **Altair**, a young white star 17 light years away, which is 11 times brighter than our Sun. It has a very fast spin, rotating

Pete Williamson remotely observed M82 with the Liverpool 2-metre f/10 reflector on La Palma, under the clear skies of the Canary Islands. He shot 9 × 90-second exposures, three each through red, green and blue filters.

in just 9 hours (as opposed to about a month for the Sun), so its equator is hurtling around at 280 kilometres per second.

Eta Aquilae is one of the brightest Cepheid variable stars – old stars that change their brightness by swelling and shrinking. The pulsations of eta Aquilae make it vary from magnitude +3.5 to +4.4 every seven days.

AUGUST'S OBJECT

The **Eagle Nebula** – no relation to the constellation Aquila! – is the go-to destination in the constellation of **Serpens** (the Serpent). In short exposures, its shape resembles a flying bird. Deeper

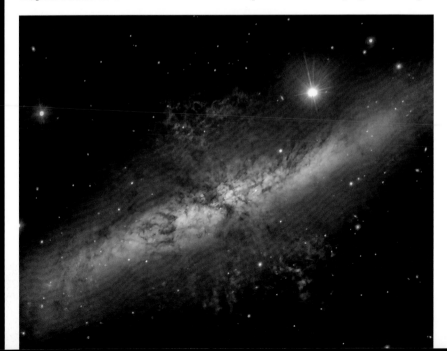

photographs reveal three dark fingers of cosmic dust, where new stars and planetary systems are being hatched, silhouetted against the glowing gas clouds. These Pillars of Creation became a celestial legend after they appeared in a stunning image from the Hubble Space Telescope. The James Webb Space Telescope has revealed more details, including newly born stars within the Pillars.

Catalogued as M16, the Eagle Nebula was discovered by Jean-Philippe Loys de Cheseaux in 1745. The gas cloud is 5700 light years away, and it's home to thousands of stars that are younger than 2 million years (less than a thousandth the age of our Sun). Through binoculars, you'll easily spot the bright baby stars, but you'll need a telescope to view the nebulosity.

AUGUST'S TOPIC: SETI

The Search for Extraterrestrial Intelligence (SETI) began a hundred years ago this month, when – in August 1924 – Mars came closer to the Earth than it had in 120 years. At the time radio stations had just started transmitting in many countries around the globe. Maybe we could listen into Martian broadcasts as the Red Planet swung by?

Sadly, all they heard was static. But with the discovery of thousands of planets orbiting other stars, researchers are now looking much further afield. Using some of the world's largest radio telescopes, Project Breakthrough has tuned into a million stars hoping to hear an interstellar call from an orbiting planet. The SETI Institute, based in California, has focused on habitable planets that the Kepler Space Telescope has discovered circling other stars.

And just in case the aliens have moved on from radio communications, the SETI Institute has also set up a pair of powerful cameras on the island of Maui, in Hawaii, that scour the skies for flashes of laser light that could be carrying encoded messages to us.

AUGUST'S PICTURE

M82 is nicknamed the Cigar Galaxy, as it resembles a tobacco roll in short exposure photographs, but Pete Williamson's deep image shows that it's actually in the trick exploding cigar category!

Long ago, M82 was an ordinary spiral galaxy like a smaller version of our Milky Way, appearing long and thin because we see it edge-on. But then its companion, M81, passed nearby and dumped a load of gas onto the cosmic cheroot, triggering a massive burst of starbirth at the galaxy's heart. In this small region, stars are forming ten times faster than they are in the entire Milky Way Galaxy.

This frenetic activity has blasted out streamers of dark dust and glowing hydrogen gas, above and below the galaxy's disc.

SUNDAY	MONDAY	TUESDAY	WEDNESDAY	THURSDAY	FRIDAY	SATURDAY
				1	2	3
4 12.13 pm New Moon	5 Moon near Venus	6	7	8	9	10 Moon near Spica
11	12 4.18 pm First Quarter Moon; Perseids	13 Perseids (am); Moon near Antares	14	15 Close conjunction of Mars and Jupiter (am)	16	17
18	19 7.25 pm Full Moon	20 Moon very near Saturn	21 Moon occults Saturn (am); Moon very near Neptune	22	23	24
25 Moon very near the Pleiades	26 10.25 am Last Quarter Moon; Moon occults Pleiades (am)	27 Moon between Jupiter and the Pleiades (am)	28 Moon near Jupiter and Mars (am)	29	30 Moon near Castor and Pollux (am)	31

SPECIAL EVENTS

- **5 August**: binoculars will show the narrowest crescent Moon just to the right of Venus, very low in the west after sunset.

- **Night of 12/13 August**: maximum of the **Perseid meteor shower**. After the Moon sets at 11 pm, it's an excellent year for observing this prolific display of shooting stars, high-speed pellets of dust from comet Swift-Tuttle burning up high overhead.

- **15 August, early hours:** Mars passes very close to Jupiter (see Planet Watch).

- **21 August, 4.28–5.21 am:** the Moon moves right in front of Saturn, hiding it from view (the times may vary by a few minutes, depending on your location). Saturn re-emerges in the morning twilight (see Planet Watch and Chart 8a).

- **21 August, 10.30 pm:** the Moon passes 5 arcminutes from Neptune (see Planet Watch).

- **26 August, early hours:** the Last Quarter Moon passes through the lower part of the Pleiades. The occulted stars include Atlas, one of the Seven Sisters, which is hidden between 4.50 and 5.30 am (the exact time depending on your location). It's a wonderful sight in binoculars or a small telescope (Chart 8b).

- **27 August, early hours:** Jupiter lies below the Moon, with Mars and Aldebaran to either side.

- **28 August, early hours:** you'll find the crescent Moon to the left of Mars, Jupiter and Aldebaran.

8a 21 August, 4.28 am. The Moon occults Saturn.

8b 26 August, 4.50 am. The Moon occults Atlas as it moves through the Pleiades.

• **Venus** skulks low in the evening twilight to the west, setting about 9 pm. Although it's more brilliant than any of the stars, at magnitude –3.9, you'll need binoculars or a telescope to spot it against the residual glow from the Sun. If you fancy a challenge, try to spot Venus with the slender crescent Moon on 5 August.

• Lying in Aquarius, **Saturn** shines at magnitude +0.7 and rises around 9 pm. The Moon occults the ringed planet in the early hours of 21 August (see Special Events). It's the first lunar occultation of Saturn visible from Britain and Ireland since 2007.

• You'll find **Neptune** (with the aid of binoculars or a telescope) in Pisces, rising about 9.30 pm. There's a convenient chance to locate this faint planet (magnitude +7.7) around 10.30 pm on 21 August, when it's the faint 'star' one-sixth of a lunar diameter above the top edge of the Moon.

• **Uranus** lies in Taurus, shining at +5.8 and rising around 11.30 pm.

• **Jupiter** shines brilliantly at magnitude –2.2 against the stars of Taurus, and rises about 0.30 am. At the start of August, **Mars** lies to the right of Jupiter, rising a few minutes earlier, and 20 times fainter at magnitude +0.9. The two planets form an equilateral triangle with the red giant Aldebaran, about the same brightness as Mars. But the Red Planet is moving rapidly leftwards, and the two planets have a close conjunction on morning of 15 August, when Mars lies only 20 arcminutes from Jupiter.

• The crescent Moon forms a lovely grouping with Jupiter and Mars – plus the Pleiades and Aldebaran – on the mornings of 27 and 28 August.

• **Mercury** is too close to the Sun to be visible this month.

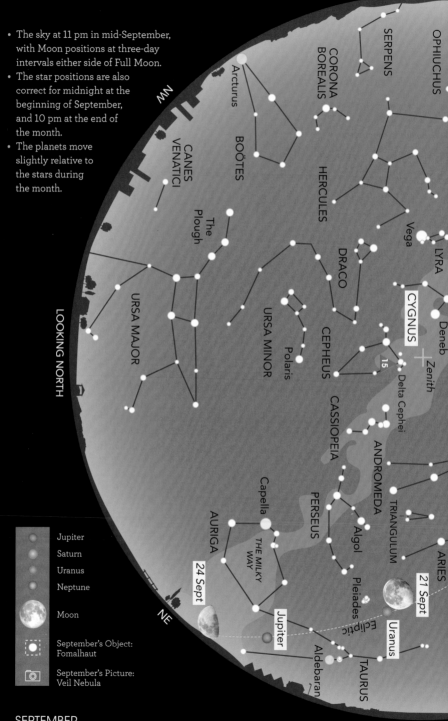

- The sky at 11 pm in mid-September, with Moon positions at three-day intervals either side of Full Moon.
- The star positions are also correct for midnight at the beginning of September, and 10 pm at the end of the month.
- The planets move slightly relative to the stars during the month.

WEST

NW

LOOKING NORTH

NE

EAST

OPHIUCHUS
SERPENS
CORONA BOREALIS
Arcturus
BOÖTES
CANES VENATICI
HERCULES
The Plough
DRACO
Vega
LYRA
Deneb
CYGNUS
Zenith
15
Delta Cephei
URSA MAJOR
URSA MINOR
Polaris
CEPHEUS
CASSIOPEIA
ANDROMEDA
TRIANGULUM
ARIES
PERSEUS
Algol
Capella
AURIGA
THE MILKY WAY
24 Sept
Jupiter
Pleiades
Uranus
21 Sept
Ecliptic
Aldebaran
TAURUS

Jupiter
Saturn
Uranus
Neptune

Moon

September's Object:
Fomalhaut

September's Picture:
Veil Nebula

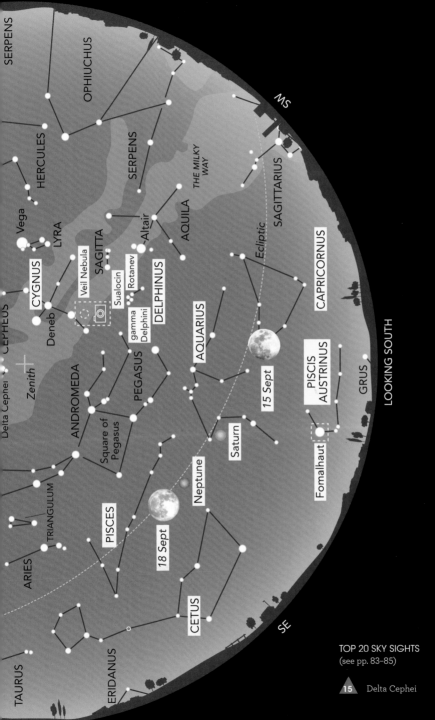

WEST

SERPENS

OPHIUCHUS

HERCULES

Vega

LYRA

CYGNUS

Deneb

CEPHEUS

Delta Cephei

Zenith

ANDROMEDA

Square of
Pegasus

TRIANGULUM

ARIES

TAURUS

ERIDANUS

EAST

Veil Nebula

SAGITTA

Sualocin

Rotanev

gamma
Delphini

DELPHINUS

PEGASUS

PISCES

18 Sept

CETUS

Altair

AQUILA

SERPENS

THE MILKY
WAY

Ecliptic

AQUARIUS

Neptune

Saturn

15 Sept

Fomalhaut

PISCIS
AUSTRINUS

GRUS

SW

SAGITTARIUS

CAPRICORNUS

LOOKING SOUTH

SE

TOP 20 SKY SIGHTS
(see pp. 83–85)

15 Delta Cephei

SEPTEMBER 57

Sky sights this month include Comet C/2023 A3 (Tsuchinshan-ATLAS) in the morning sky, a dawn appearance by Mercury, a shallow eclipse of the Moon, and **Saturn** at its best. On the starry front, the sky is awash with watery constellations. **Piscis Austrinus** (the Southern Fish) wallows in a stream poured by **Aquarius** (the Water Carrier); they are surrounded by **Delphinus** (the Dolphin), the strangely named Sea Goat (**Capricornus**), a pair of Fishes (**Pisces**) and **Cetus** (the Sea Monster).

SEPTEMBER'S CONSTELLATION

It may be small, but it's perfectly formed. **Delphinus**, the celestial dolphin, is outlined by four stars making a lopsided rectangle, with an extra star forming its tail.

According to one myth, the dolphin acted as match-maker between the sea god Poseidon and the nymph Amphitrite. In another story, the dolphin rescued the musician Arion when he was thrown overboard by sailors intent on stealing his wealth.

Gamma Delphini is a lovely double star in a moderately powerful telescope. Two other stars bear the intriguing names **Sualocin** and **Rotanev**. These are a bit of blatant self-promotion by an Italian astronomer, Niccolò Cacciatore, known in Latin as Nicolaus Venator: try spelling his name backwards!

SEPTEMBER'S OBJECT

I've always had a soft spot for the star **Fomalhaut**. From my childhood home in Northern Ireland, it was an annual challenge to spot this southerly luminary barely scraping above the horizon. To the ancients, Fomalhaut was the mouth of **Piscis Austrinus** (the Southern Fish), gulping the stream of water poured by **Aquarius** (the Water Carrier).

To astronomers today, Fomalhaut is most famous for its disappearing planet.

In 2008, astronomers announced they had imaged a planet orbiting within the dusty disc that surrounds Fomalhaut. They even gave it a name: Dagon, after a Middle Eastern fish god. But over the years, Dagon has faded away. We now think it was never a planet at all, but just a bright cloud of dust that erupted when two asteroids or comets collided.

SEPTEMBER'S TOPIC: PLANETARY NEBULAE

William Herschel – who discovered the planet **Uranus** – first named these fuzzy objects 'planetary nebulae', because, to him, they looked like the planet he had just found. Now we know that they are the end-point for a star like the Sun.

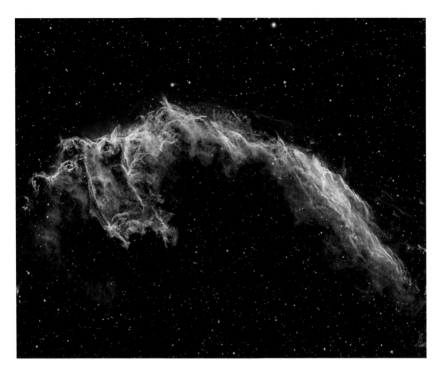

When the star runs out of the nuclear fuel that keeps it shining, its core contracts and heats up, pumping out extra energy that makes the outer layers swell up. The star has become a red giant. But the distended outer layers become unstable, pulsating so violently that shells of gas and dust are ejected into space. The exposed super-hot core lights up the ejecta as a beautiful planetary nebula. It's only a matter of 10,000 years, though, before the nebula dissipates and the star's core is left as a white dwarf.

SEPTEMBER'S PICTURE

The haunting wraiths of the **Veil Nebula** in **Cygnus** are the remains of a star that exploded around 20,000 years ago. The twisted filaments form part of a giant expanding bubble called the Cygnus

From his home in Nottinghamshire, Peter Jenkins took this image over several nights in September 2022, using a 200-mm Officina Stellare RH200 telescope equipped with hydrogen alpha and oxygen filters and an Atik Horizon CMOS camera. Peter took 26 × 300-second exposures through each filter, giving a total exposure time of just over 4 hours, and processed the result in PixInsight and Photoshop.

Loop – gas from the supernova explosion mixed with interstellar material that it's swept up. The different gases glow in a rainbow of colours, seen clearly in Peter Jenkins's image where hydrogen atoms are shining red and the light from oxygen atoms appears blue.

The compressed gas and dust in the Veil Nebula will one day condense into stars: like a phoenix, the ashes of the old star will give birth to a new generation that rises from its flames.

SUNDAY	MONDAY	TUESDAY	WEDNESDAY	THURSDAY	FRIDAY	SATURDAY
1	2	3 2.55 am New Moon	4	5 Mercury W elongation; Moon near Venus	6	7
8 Saturn opposition; Mars near M35	9 Mars near M35 (am); Mercury near Regulus (am)	10 Moon near Antares	11 7.05 am First Quarter Moon	12	13	14
15	16 Moon near Saturn	17 Moon near Saturn	18 3.34 am Full Moon; supermoon; partial lunar eclipse (am)	19	20 Neptune opposition	21
22 Autumn Equinox	23 Moon near Jupiter	24 7.49 pm Last Quarter Moon	25	26 Moon between Mars and Castor and Pollux (am)	27	28 Comet Tsuchinshan-ATLAS at perihelion
29 Moon near Regulus (am)	30					

SPECIAL EVENTS

• **5 September, before dawn:** Mercury is at its greatest separation from the Sun (see Planet Watch).

• **5 September:** the narrowest crescent Moon lies just to the left of Venus, very low in the west after sunset: best seen in binoculars.

• **8 September:** Saturn is opposite to the Sun, and nearest to the Earth at 1295 million km (see Planet Watch).

• **Night of 8/9 September:** Mars passes below the M35 star cluster (see Planet Watch and Chart 9a).

• **9 September, before dawn:** Mercury lies near Regulus (see Planet Watch).

• **18 September:** the first of three **supermoons** this year (see October's Special Events)

suffers a partial eclipse visible from Europe, Africa and the Americas. But only 8 per cent of the Moon is obscured by the Earth's shadow at maximum eclipse (3.44 am). The eclipse lasts from 3.12 to 4.15 am.

• **20 September:** Neptune is opposite to the Sun, and nearest to the Earth at 4322 km (see Planet Watch).

• **22 September, 1.43 pm:**

nights become longer than days as the Sun moves south of the equator at the Autumn Equinox.

• **23 September:** the bright 'star' below the Moon is Jupiter.

• **28 September, before dawn:** Comet Tsuchinshan-ATLAS should be around magnitude +1 as it passes closest to the Sun (Chart 9b), and continues to brighten as it nears the Earth.

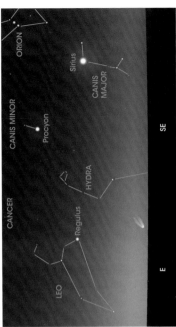

9a 9 September, 4 am. Mars passes below M35.

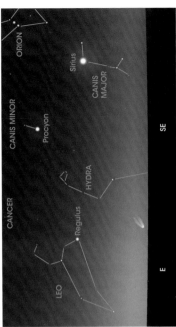

9b 28 September, 6 am. Comet Tsuchinshan-ATLAS beneath Leo, with Procyon and Sirius to the right.

- Very low in the western sky after sunset, **Venus** is hugging the horizon all month: binoculars will help you ferret it out from the glowing sky. The Evening Star is a brilliant magnitude –3.9, and sets about 8 pm. The Moon passes nearby on 5 September.
- **Saturn** is closest to the Earth and opposite the Sun on 8 September (see Special Events), when the planet is at its brightest this year, magnitude +0.6. It's visible all night long in Aquarius. A small telescope shows Saturn's famous rings – currently appearing almost edge-on – along with its biggest moon, Titan.
- **Neptune**, in Pisces, reaches opposition on 20 September (see Special Events) and is above the horizon all night. Even at its nearest, the furthest planet is below naked eye visibility (magnitude +7.7) and you'll need binoculars or a telescope to see it.

- Its near-twin, **Uranus** (magnitude +5.7) lies in Taurus and rises around 9 pm.
- Also in Taurus, brilliant **Jupiter** rises about 10.30 pm and shines at magnitude –2.4. The Moon is nearby on 23 September.
- **Mars** travels from Taurus to Gemini during the month, gliding below the pretty star cluster M35 (February's Object) on the night of 8/9 September (Chart 9a). At magnitude +0.6, the Red Planet is rising at around 11.30 pm.
- During the first two weeks of September, **Mercury** puts on its best morning show of the year, low in the east before dawn. At greatest elongation on 5 September, the innermost planet shines at magnitude –0.2 and rises about 4.40 am. Mercury grows brighter, passing Regulus on the morning of 9 September, but by mid-month it has sunk into the twilight glow.

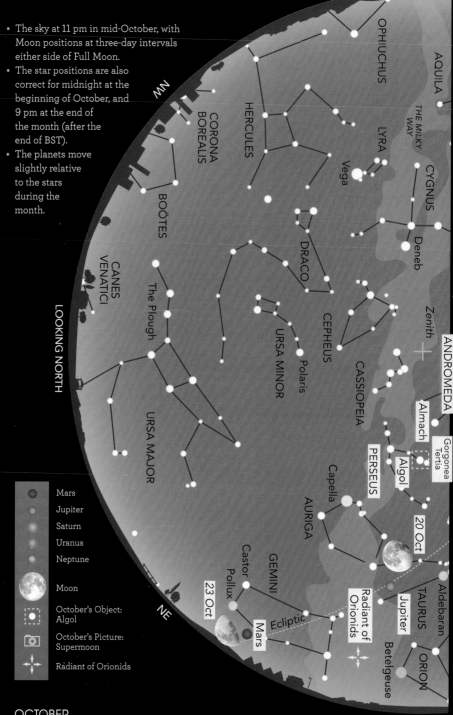

- The sky at 11 pm in mid-October, with Moon positions at three-day intervals either side of Full Moon.
- The star positions are also correct for midnight at the beginning of October, and 9 pm at the end of the month (after the end of BST).
- The planets move slightly relative to the stars during the month.

WEST

NW

LOOKING NORTH

NE

EAST

OPHIUCHUS
AQUILA
THE MILKY WAY
CORONA BOREALIS
HERCULES
LYRA
Vega
CYGNUS
Deneb
BOÖTES
DRACO
Zenith
CANES VENATICI
The Plough
CEPHEUS
ANDROMEDA
URSA MINOR
Polaris
CASSIOPEIA
Almach
Gorgonea Tertia
PERSEUS
Algol
URSA MAJOR
Capella
AURIGA
20 Oct
Castor
GEMINI
Pollux
Radiant of Orionids
TAURUS
Aldebaran
Jupiter
23 Oct
Mars
Ecliptic
ORION
Betelgeuse

Mars
Jupiter
Saturn
Uranus
Neptune
Moon
October's Object: Algol
October's Picture: Supermoon
Radiant of Orionids

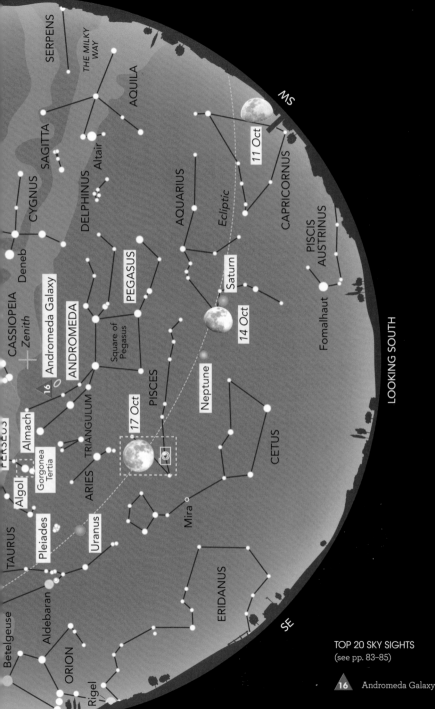

SERPENS

THE MILKY WAY

SAGITTA

AQUILA

Altair

CYGNUS

DELPHINUS

Deneb

CASSIOPEIA
+ Zenith

Andromeda Galaxy

ANDROMEDA

PEGASUS

Square of Pegasus

AQUARIUS

Ecliptic

11 Oct

CAPRICORNUS

Saturn

14 Oct

PISCIS AUSTRINUS

Fomalhaut

Neptune

PISCES

17 Oct

TRIANGULUM

PERSEUS

Almach

Algol

Gorgonea Tertia

ARIES

Mira

CETUS

TAURUS

Pleiades

Uranus

Aldebaran

ERIDANUS

Betelgeuse

ORION

Rigel

16 ◇

SW

S

LOOKING SOUTH

SE

OCTOBER

TOP 20 SKY SIGHTS
(see pp. 83–85)

16 Andromeda Galaxy

Comet C/2023 A3 (Tsuchinshan-ATLAS) appears in the evening sky this month, if it's survived its fiery passage by the Sun, and may – just possibly – blaze in the sky. And look to the east, where the brilliant lights of winter are starting to appear, spearheaded by the **Pleiades**. They are partially occulted by the Moon a couple of days after the best supermoon of 2024.

OCTOBER'S CONSTELLATION

It may look like a simple line of stars linked to **Pegasus**, but the ancient Greeks saw **Andromeda** as a young princess chained to a rock, about to be devoured by a sea monster. Andromeda contains some surprising delights. **Almach**, the star at the left-hand end of the line, is a lovely sight in small telescopes: this beautiful double star

As the supermoon rose on 12 August 2022, tinted orange by its low elevation, Denis Walsh seized the opportunity to capture it sailing over a 19th-century signal tower. His equipment was simply a Nikon D600 camera and a 'small, cheap refractor' with a 700-mm focal length.

comprises a yellow supergiant shining 2000 times brighter than the Sun, and a fainter bluish companion which is in fact triple.

But the glory of Andromeda is its great galaxy, beautifully placed on October nights. Lying above the line of stars, the **Andromeda Galaxy** is the most distant object easily visible to the unaided eye, a mind-boggling 2.5 million light years away. Containing 400 billion stars, the Andromeda Galaxy is the biggest member of the Local Group of galaxies. A telescope reveals the galaxy's faint outer regions covering an area several times larger than the Moon.

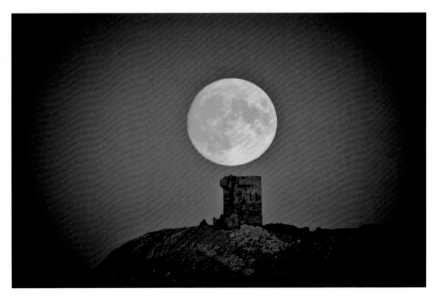

OCTOBER'S OBJECT

The star **Algol**, in the constellation **Perseus**, represents the head of the dreadful Gorgon Medusa. In Arabic, its name means 'the Demon'. Watch Algol carefully and you'll see why. Every 2 days 21 hours, Algol dims in brightness for several hours – to become as faint as the star lying next door (**Gorgonea Tertia**).

In 1783, an 18-year-old, profoundly deaf amateur astronomer from York – John Goodricke – discovered Algol's regular changes, and proposed that the star was orbited by a large dark planet that periodically blocks off some of its light. We now know that Algol does indeed have a dim companion blocking its brilliant face; but it's a fainter star, rather than a planet. While the main star is 180 times more luminous than the Sun, and a searing blue-white in colour, the dimmer red companion is only seven times brighter than our local star.

OCTOBER'S TOPIC: GEORGES LEMAÎTRE

The idea that the Universe began in an exploding Big Bang wasn't proposed by a big-name astronomer, but by a modest Belgian priest. Georges Lemaître (1894–1966) had studied science at university. When he heard through the astronomical grapevine that distant galaxies are racing away from us, Lemaître – in 1927 – was the first to suggest it's because the whole Universe is expanding.

Four years later, he took an even bolder step, declaring that the Universe sprang from 'a Cosmic Egg, exploding at the moment of the creation'. Today, Lemaître's exploding egg is known as the Big Bang.

Albert Einstein was among the sceptics. The problem? Science says there

must be a cause for everything that takes place; and the Big Bang was an event without a cause. It took a polymath like Georges Lemaître to eventually persuade scientists that the Big Bang was a unique event that 'just happened,' and gave birth to our Cosmos.

OCTOBER'S PICTURE

Sometimes it's all about timing and composition, rather than a sophisticated telescope, when it comes to capturing a stunning astronomical image – as Denis Walsh exemplifies in this shot of a **supermoon** rising over the signal tower at Black Ball Head in County Cork, Ireland.

We're treated to the best supermoon of 2024 on 17 October. Defined as a Full Moon that's nearer than 360,000 kilometres to the Earth, a supermoon appears 14 per cent larger and 30 per cent brighter than when our companion world is at its most distant point. Typically there are three consecutive supermoons in a year, with the middle one being the closest.

SUNDAY	MONDAY	TUESDAY	WEDNESDAY	THURSDAY	FRIDAY	SATURDAY
		1	2 — 7.49 pm New Moon; annular solar eclipse	3	4	5 — Moon near Venus
6	7 — Moon near Antares	8	9	10 — 7.55 pm First Quarter Moon	11	12
13 — Comet Tsuchinshan-ATLAS nearest to Earth	14 — Moon near Saturn	15	16	17 — 12.26 pm Full Moon; supermoon	18	19 — Moon occults the Pleiades
20 — Moon near Jupiter	21 — Moon near Jupiter; Orionids	22 — Orionids (am); Moon near Castor and Pollux	23 — Moon near Mars, Castor and Pollux	24 — 9.03 am Last Quarter Moon	25	26
27 — BST and IST end; Moon near Regulus (am)	28	29	30	31		

SPECIAL EVENTS

- **2 October:** an annular eclipse of the Sun is visible from Rapa Nui (Easter Island) and the southern tip of South America.
- **5 October:** the crescent Moon lies beneath Venus, low in the dusk twilight (best seen in binoculars).
- **13 October:** Comet **Tsuchinshan-ATLAS** appears in the evening twilight as it passes the Earth, 70 million km away, but it's difficult to predict the comet's brightness: predictions range from magnitude −3 with a long tail (Chart 10a) to a complete non-show if it disintegrated when it passed the Sun last month. If the comet has survived, it should be visible till the end of the month (use binoculars when the Moon is bright).
- **14 October:** the Moon glides right under Saturn.
- **17 October:** the largest and brightest **supermoon** this year, with the Full Moon lying just 357,367 km from the Earth.
- **19 October 7.30–10.30 pm:** the Moon passes just below the centre of the Pleiades cluster, occulting some of its stars.
- **20 October:** Jupiter lies below the Moon.
- **21 October:** Jupiter lies to the right of the Moon.
- **Night of 21/22 October:** the **Orionid meteor shower** is sadly washed out by bright moonlight.
- **23 October:** the Moon lies near Mars, Castor and Pollux (Chart 10b).
- **27 October, 2 am:** the end of British Summer Time and Irish Standard Time.

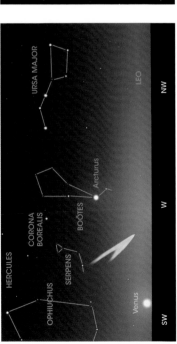

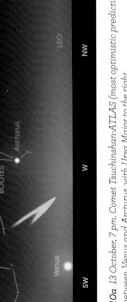

10a 13 October, 7 pm. Comet Tsuchinshan-ATLAS (most optimistic prediction) between Venus and Arcturus, with Ursa Major to the right.

10b 23 October 11.30 pm. The Moon with Castor, Pollux and Mars.

• **Venus** appears low in the south-west after the Sun goes down, setting just after 7 pm. Despite its brilliance (magnitude −4.0), you'll need binoculars to spot the Evening Star in the bright evening twilight, and to see the narrow crescent Moon just below it on 5 October.

• Setting around 3.30 am, **Saturn** shines in Aquarius at magnitude +0.7. During the evening of 14 October, watch the Moon pass right under the ringed planet, just 35 arcminutes (about one Moon's-width) away.

• **Neptune**, in Pisces, is below naked-eye visibility at magnitude +7.7. The outermost planet sets about 5 am.

• Not far from the Pleiades in Taurus, you'll find **Uranus** at a dim magnitude +5.7 and rising around 7 pm.

• Brilliant **Jupiter** lies at the left-hand side of Taurus, between the 'horns' of the Bull, shining at magnitude −2.6. The giant planet rises about 8.30 pm. The Moon lies nearby on 20 and 21 October.

• Rising around 11 pm, **Mars** shines at magnitude +0.3 in Gemini. The Last Quarter Moon passes by on 23 October (Chart 10b), and the Red Planet is in line with Castor and Pollux right at the end of the month.

• **Mercury** is lost in the Sun's glare in October.

OCTOBER

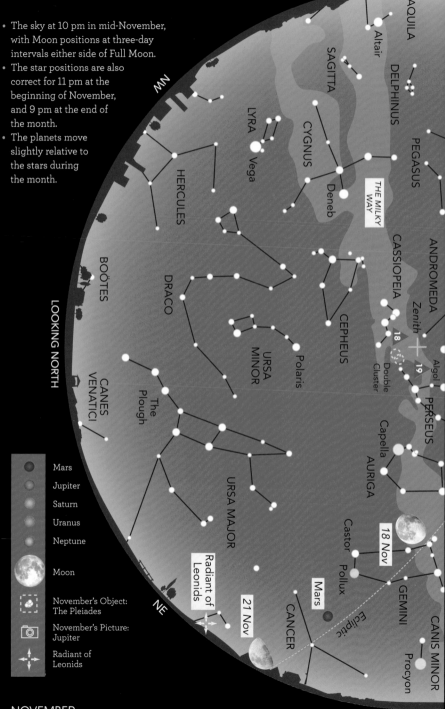

- The sky at 10 pm in mid-November, with Moon positions at three-day intervals either side of Full Moon.
- The star positions are also correct for 11 pm at the beginning of November, and 9 pm at the end of the month.
- The planets move slightly relative to the stars during the month.

WEST

AQUILA
Altair
DELPHINUS
SAGITTA
PEGASUS
LYRA
Vega
CYGNUS
Deneb
THE MILKY WAY
CASSIOPEIA
ANDROMEDA
Zenith
HERCULES
BOÖTES
DRACO
CEPHEUS
18
Double Cluster
Algol
19
PERSEUS
URSA MINOR
Polaris
CANES VENATICI
The Plough
Capella
AURIGA
URSA MAJOR
Castor
Pollux
18 Nov
GEMINI
Radiant of Leonids
21 Nov
Mars
CANCER
CANIS MINOR
Procyon
Ecliptic

LOOKING NORTH

NW
NE
EAST

Mars
Jupiter
Saturn
Uranus
Neptune
Moon
November's Object: The Pleiades
November's Picture: Jupiter
Radiant of Leonids

NOVEMBER

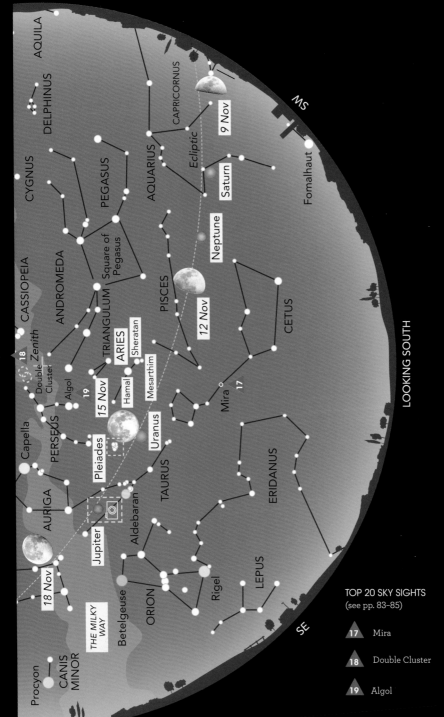

AQUILA

CYGNUS

DELPHINUS

CASSIOPEIA

PEGASUS

CAPRICORNUS

ANDROMEDA

AQUARIUS

Ecliptic

9 Nov

MS

Saturn

Fomalhaut

Square of
Pegasus

TRIANGULUM

Neptune

Zenith

PISCES

12 Nov

Double
Cluster

ARIES

CETUS

Algol

Sheratan

19

Mesarthim

15 Nov

Hamal

Mira 17

Capella

PERSEUS

Uranus

Pleiades

TAURUS

ERIDANUS

AURIGA

Jupiter

Aldebaran

18 Nov

THE MILKY
WAY

Betelgeuse

ORION

Rigel

LEPUS

SE

Procyon

CANIS
MINOR

EAST

NOVEMBER

NOVEMBER

TOP 20 SKY SIGHTS
(see pp. 83–85)

17 Mira

18 Double Cluster

19 Algol

We have a brilliant Evening Star! After months skulking in the twilight zone, Venus shoots upwards into darker skies this month. There's more subtle beauty in the **Milky Way,** rearing overhead on these long November nights and providing an inside perspective on our own home Galaxy. Sweep along the glowing band with binoculars, you'll find it studded with star clusters and nebulae.

NOVEMBER'S CONSTELLATION

Aries has only three moderately bright stars – **Hamal** and **Sheratan** and fainter **Mesarthim** – making up the head of the celestial ram. It has, however, a long and distinguished pedigree. Around 2000 years ago, the Sun crossed the celestial equator in Aries at the Spring Equinox, as it climbed higher in northern skies every year: astronomers still call this cosmic intersection 'the First Point of Aries,' even though it now lies in Pisces.

In Greek mythology, this aerobatic ovine swooped down to rescue the hero Phrixos. He rewarded the poor ram by sacrificing it to the gods, hanging up its skin as the coveted 'golden fleece'.

Of the three main stars, Mesarthim – the faintest – is the most interesting. It's a double star, consisting of two equally bright white stars easily visible through a small telescope.

NOVEMBER'S OBJECT

The **Pleiades** star cluster is one of the most familiar sky sights. It is lovely seen with the naked eye or through binoculars, and magnificent in a long-exposure image.

Though the cluster is well known as the Seven Sisters, skywatchers typically see any number of stars but seven! Most people can pick out the six brightest stars, while very keen-sighted observers

OBSERVING TIP

With Christmas on the way, you may be thinking of buying a telescope as a present for a budding stargazer. Beware! Unscrupulous websites and mail-order catalogues often advertise small telescopes that boast huge magnifications, but all they do is show you a large blurry image. To see planets and stars sharply, you need to use a magnification no more than twice the diameter of the lens or mirror in millimetres. So if you see an advertisement for a 75-millimetre telescope, beware of any claims for a magnification greater than 150 times.

can discern up to 11 members. These are just the most luminous in a group of at least 1000 stars, lying 440 light years away. The brightest stars in the Pleiades are hot and blue, and all the stars are young – around 100 million years old (about 2 per cent of the Sun's age).

NOVEMBER'S TOPIC: RADIO ASTRONOMY

In 1942, British wartime scientists were shocked that their radar antennae were being overwhelmed by powerful radio transmissions: were the Germans jamming the Allies' early warning system? In fact, flares on the Sun were the culprit. And the discovery marked the birth of radio astronomy, the investigation of

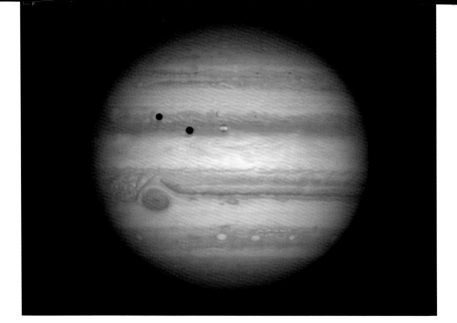

Damian Peach caught this double shadow-transit of Io and Europa at 5 am on 22 March, 2016, using his 356-mm Celestron C14 Schmidt-Cassegrain telescope with an ASI120MM-S camera.

radio waves from celestial objects.

While ordinary optical telescopes show us generally placid objects, like stars and nebulae, radio telescopes reveal a violent Cosmos, replete with the fireballs from exploding stars (supernova remnants) and intensely small but energic star corpses known as neutron stars, that send us regular pulses of radio waves as they wildly gyrate.

Radio astronomers have found vast fountains of energy powered by the gravity of supermassive black holes in the centres of galaxies. Using radio telescopes linked across the Earth, they've even glimpsed the silhouette of the black hole at the core of the Milky Way.

Other researchers tune into specific wavelengths emitted by atoms and molecules. These radio waves allow us to map the gas that fills the Milky Way and other galaxies, and also reveal how the material swirling around baby stars is condensing into systems of alien planets.

NOVEMBER'S PICTURE

Jupiter's massive storm, the Great Red Spot, is well displayed in this image taken by Damian Peach. But what about the two black spots above? Look more closely, and you can see they are shadows cast by two of the planet's moons (see December's Objects) moving in front of the planet in a **double shadow-transit**: orange Io and (above it) brilliant white Europa, more difficult to see against Jupiter's pale clouds.

You can catch any of Jupiter's four biggest moons transiting as they orbit the giant planet, along with the shadows they cast on the planet below. But a double shadow-transit usually involves Io and Europa. Not only are they the closest moons to Jupiter – and so transit more frequently – but also their orbits are synced: for each orbit made by Europa, Io completes exactly two orbits.

SUNDAY	MONDAY	TUESDAY	WEDNESDAY	THURSDAY	FRIDAY	SATURDAY
					1 12.47 pm New Moon	2
3	4	5 Moon near Venus	6	7	8	9 5.55 am First Quarter Moon
10 Moon near Saturn	11	12	13	14	15 9.28 pm Full Moon; supermoon	16 Mercury E elongation
17 Uranus opposition; Moon near Jupiter; Leonids	18 Leonids (am)	19 Moon near Castor and Pollux	20 Moon near Mars	21	22 Moon near Regulus	23 1.28 am Last Quarter Moon
24	25	26	27 Moon near Spica (am)	28	29	30

Leonid meteor shower

SPECIAL EVENTS

- **5 November:** low in the dusk twilight, look for the crescent Moon to the left of Venus (Chart 11a).
- **10 November:** the Moon lies below Saturn.
- **15 November:** the last of the three supermoons that occur in 2024 (see October's Special Events).
- **17 November:** Uranus is at its closest to the Earth – 2778 million km away – and opposite to the Sun in the sky (see Planet Watch).
- **17 November:** the bright 'star' located near the Moon is Jupiter.
- **Night of 17/18 November:** sadly, strong moonlight will drown out most of the shooting stars from the annual **Leonid meteor shower** – fragments of Comet Tempel-Tuttle impacting our atmosphere at high speed.
- **20 November:** the Moon passes to the left of Mars with Castor and Pollux to the upper right (Chart 11b).

11a 5 November, 5 pm. Venus next to the crescent Moon.

11b 20 November, 11 pm. The Moon with Mars, near to Castor and Pollux.

• **Venus** starts the month low in the evening twilight, setting at 6 pm: the crescent Moon lies nearby on 5 November (Chart 11a). But it's steaming upwards: by the end of November the Evening Star sets just before 7 pm, and you'll see it against the dark night sky. The planet shines like a steady beacon, a stunning sight at magnitude −4.1.

• **Saturn** lies in Aquarius, shining at magnitude +0.9 and setting around 0.30 am.

The Moon is just below the planet on 10 November.

• On the border of Aquarius and Pisces, distant **Neptune** glows at a mere magnitude +7.7 and sets about 2 am.

• **Uranus** is at its closest and brightest on 17 November (see Special Events), and above the horizon all night long. At magnitude +5.6 the planet is just visible to the naked eye on a really dark night, away from light pollution and moonlight. But on the positive side, it's

high in the sky (in Taurus, near the Pleiades) and unobscured by haze. Seek out Uranus when the Moon is out of the way, near the beginning or the end of the month, and add it to the tally of planets you've seen with unaided eyes.

• Giant planet **Jupiter** is brilliant in Taurus, at magnitude −2.8 and rising around 5.30 pm. The Moon lies to the left of Jupiter on 17 November, with Aldebaran to the right.

• Rising about 9 pm, **Mars** lies in Cancer and brightens during the month from magnitude +0.1 to −0.5 as the Earth approaches. The Moon glides past the Red Planet on 20 November (Chart 11b). Right at the end of the month, you'll find Mars just above the star cluster Praesepe.

• **Mercury** is lost in the bright twilight glow in November, even at its greatest separation from the Sun on 16 November.

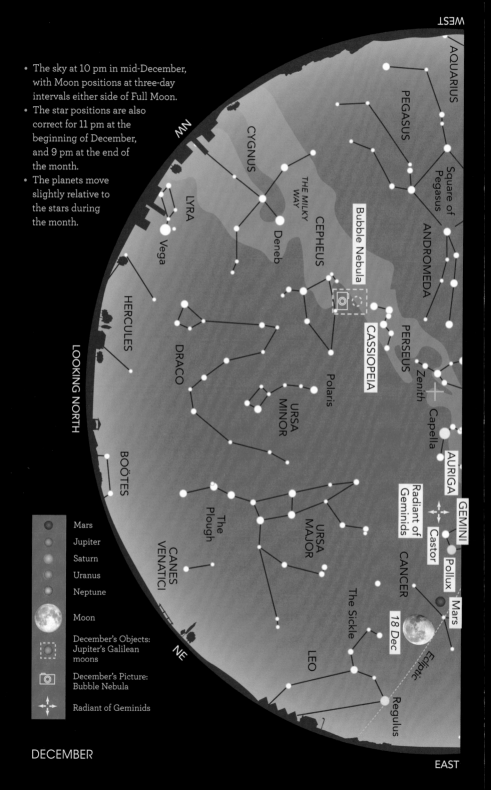

- The sky at 10 pm in mid-December, with Moon positions at three-day intervals either side of Full Moon.
- The star positions are also correct for 11 pm at the beginning of December, and 9 pm at the end of the month.
- The planets move slightly relative to the stars during the month.

WEST

AQUARIUS

PEGASUS

Square of Pegasus

CYGNUS

THE MILKY WAY

ANDROMEDA

Bubble Nebula

LYRA

CEPHEUS

Vega

Deneb

PERSEUS

CASSIOPEIA

HERCULES

DRACO

Polaris

Zenith

Capella

URSA MINOR

AURIGA

BOÖTES

The Plough

URSA MAJOR

Radiant of Geminids

GEMINI

Castor

Pollux

Mars

CANCER

CANES VENATICI

LEO

The Sickle

18 Dec

Regulus

Ecliptic

NE

LOOKING NORTH

Mars
Jupiter
Saturn
Uranus
Neptune

Moon

December's Objects: Jupiter's Galilean moons

December's Picture: Bubble Nebula

Radiant of Geminids

DECEMBER

EAST

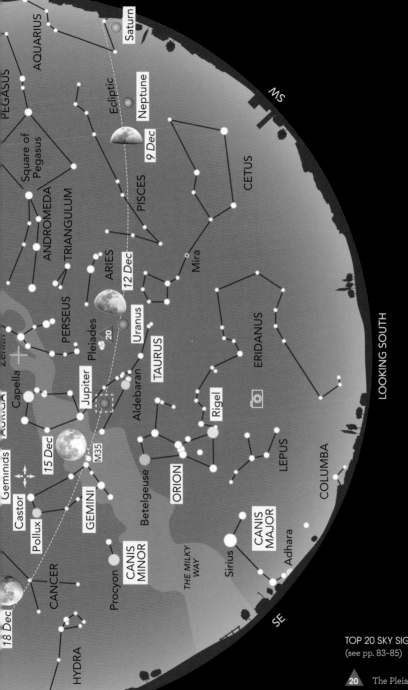

WE

Saturn

AQUARIUS

PEGASUS

Ecliptic

Neptune

9 Dec

Square of
Pegasus

ANDROMEDA

TRIANGULUM

PERSEUS

ARIES

12 Dec

Mira

PISCES

CETUS

MS

Pleiades

20

Uranus

TAURUS

Capella

Jupiter

Aldebaran

Rigel

ERIDANUS

LOOKING SOUTH

Geminids

15 Dec

M35

Betelgeuse

ORION

LEPUS

COLUMBA

Castor

Pollux

GEMINI

CANIS
MINOR

Procyon

Sirius

CANIS
MAJOR

Adhara

THE MILKY
WAY

18 Dec

CANCER

HYDRA

SE

TOP 20 SKY SIGHTS
(see pp. 83–85)

20 The Pleiades

AST

Lo and behold not one Christmas Star, but two! Brilliant Venus hangs like a lantern in the west, while giant planet **Jupiter** is high in the south – both at their most spectacular this year. The stars, too, are putting on a celebratory show, featuring **Orion** with his hunting dogs **Canis Major** and **Canis Minor**, and his adversary **Taurus** (the Bull), along with the hero twins of **Gemini** and the charioteer **Auriga**.

DECEMBER'S CONSTELLATION

The constellation of the celestial twins – **Gemini** – is crowned by the bright stars **Castor** and **Pollux**, representing the heads of the mythological brethren. In legend they were conceived by princess Leda on the same day, Castor by her human husband, and immortal Pollux by chief god Zeus. After Castor's death, Zeus placed them together for eternity among the stars.

Castor is an amazing family of six stars. Through a small telescope, you can see that it's a close double, with a fainter companion lying further away. And all three of these stars are themselves very tight-knit pairs. Pollux – cooler and orange in hue – is the nearest giant star to the Sun. Gemini also boasts a pretty star cluster, **M35** (see February's Object).

OBSERVING TIP

Venus is glorious this month. Through a small telescope, you can make out its cloud-wreathed globe, half-lit by the Sun. But don't wait for the sky to get totally dark. Seen against a black sky, Venus is so brilliant it's difficult to discern any details. You're best off viewing Venus soon after the Sun has set, when the Evening Star first becomes visible in the twilight glow. Through a telescope, the planet then appears less dazzling against a pale blue sky.

DECEMBER'S OBJECTS

Mighty **Jupiter** boasts 92 moons – at the latest count! They are all pretty puny, apart from four moons that are large enough to qualify as planets themselves, if they were orbiting the Sun. Sharp-eyed people can spot them with the unaided eye, and they're easily visible in binoculars as they move around Jupiter from night to night.

These **Galilean moons** were observed by Galileo with his telescope in 1610, and named by German astronomer Simon Marius after various lovers of the god Jupiter. Nearest to the planet is yellow-orange Io, stained by eruptions from giant volcanoes. Next is enigmatic Europa, whose brilliant white icy surface overlies a deep ocean where – possibly – some kind of alien aquatic life may thrive. Ganymede, at 5268 kilometres across, is the biggest moon in the Solar System, even larger than the planet Mercury. The outermost of the four, Callisto, is totally covered with craters.

DECEMBER'S TOPIC: NAMES OF THE PLANETS

One of the most unusual questions I've been asked goes along the lines: 'How do astronomers know the names of the planets?' Mercury, Venus, Mars … these names are so familiar that they seem intrinsic to our companions in space. But

they were all bestowed by humans in the distant past.

The Mesopotamians, 3000 years ago, saw these bright celestial lights as personifications of their gods. The brilliant planet that appeared as the Morning or Evening Star was Ishtar, goddess of love (and also, sometimes, war). The Red Planet represented Nergal, god of death, war and disease; while the stately planet that can shine all night long was the king of gods, Marduk. You can easily see how these planets became sacred to the corresponding Roman gods Venus, Mars and Jupiter.

The Greeks characterised the fastest-moving planet as the messenger of the gods, and the slowest planet as the god who marks time and the harvest – our Mercury and Saturn.

But it wasn't about deities in all cultures. In ancient China, the planets represented the five Chinese elements. Rapidly moving Mercury was the planet of water, while shiny Venus was the metal planet. Not surprisingly, Mars represented fire. Jupiter was the planet of wood, while dim, slow-moving Saturn represented earth.

DECEMBER'S PICTURE

A giant brooding cloud of gas and dust 8500 light years away in **Cassiopeia** is hatching new stars in its hidden depths. One day, this region will be filled with brilliant stellar youngsters; but at the moment all we see is the dimly lit front of the dense molecular cloud. Andy Weller has removed all the stars to enhance the 'dark and moody' nature of his photographic subject.

Central in this view is the aptly named **Bubble Nebula**. Despite appearances, it's far from fragile. The nebula is a tempestuous ball of hot gas that's being blasted into space by an intensely energetic star – the first of the new generation to emerge from the stellar nursery. This cosmic bubble, also known as NGC 7635, is 10 light years across.

Observing from Bedfordshire with a 280-mm Celestron C11 Schmidt-Cassegrain telescope at f/6.3, Andy Weller equipped his ZWO ASI294MC Pro OSC camera with an Optolong L-Ultimate LP filter to pass hydrogen alpha and oxygen light while cutting down on light pollution. He took 48 × 300-second exposures, and stacked and processed the images in PixInsight, using StarNet 2 software to automatically remove the star images.

SUNDAY	MONDAY	TUESDAY	WEDNESDAY	THURSDAY	FRIDAY	SATURDAY
1 6.21 am New Moon	2	3	4 Moon near Venus	5 Moon near Venus	6 Jupiter closest to Earth	7 Jupiter opposition
8 3.26 pm First Quarter Moon near Saturn	9	10	11	12	13 Moon near the Pleiades	14 Moon near Jupiter; Geminids
15 9.01 am Full Moon; Geminids (am)	16	17 Moon between Mars and Castor and Pollux	18 Moon very near Mars (am) with daytime occultation	19 Moon near Regulus	20	21 Winter Solstice
22 10.18 pm Last Quarter Moon	23	24	25 Moon near Spica (am); Mercury W elongation	26	27	28 Moon near Mercury
29	30 10.26 pm New Moon	31				

SPECIAL EVENTS

- **4 December:** Venus and the thin crescent Moon below make a striking sight low in twilight sky to the south-west (Chart 12a).
- **5 December:** Venus lies to the right of the crescent Moon after sunset (Chart 12a).
- **6 December:** Jupiter is closest to the Earth, 612 million km away (see Planet Watch).
- **7 December:** Jupiter lies opposite to the Sun in the sky.
- **13 December:** the Moon skims under the Pleiades.
- **14 December:** Jupiter lies below the Moon, with Aldebaran to the lower right.
- **Night of 14/15 December:** bright moonlight spoils the **Geminid meteor shower,** dust from asteroid Phaethon blazing in Earth's atmosphere.
- **Night of 17/18 December:** you'll find the Moon lying between Mars (left) and Castor and Pollux (upper right). After dawn the Moon occults Mars (see Planet Watch).
- **21 December, 9.20 am:** the Winter Solstice, when the Sun reaches its southernmost, giving the northern hemisphere the shortest day and the longest night.
- **25 December, before dawn:** Mercury is at its greatest separation from the Sun (see Planet Watch).
- **28 December, before dawn:** look carefully to the left of the crescent Moon low in the morning twilight to glimpse the elusive planet Mercury, with Antares between them (Chart 12b).

12a 4–5 December, 5.30 pm. The crescent Moon near Venus.

12b 28 December, 7 am. Mercury with the crescent Moon and Antares.

• You can't miss **Venus**, effulgent in the south-west after sunset. By the end of December, the Evening Star reaches magnitude –4.4 and stays above the horizon until after 8 pm, so we see it against the dark winter sky. There's a lovely sight on the evenings of 4 and 5 December as Venus is joined by the slender crescent Moon (Chart 12a).

• Well to Venus's upper left, and over 100 times fainter at magnitude +1.0, you'll find **Saturn.** The ringed planet lies in Aquarius and sets about 11 pm, with the First Quarter Moon passing to its left on 8 December.

• **Neptune** is on the border of Aquarius and Pisces; at magnitude +7.8, it's setting around midnight.

• Slightly brighter **Uranus** (magnitude +5.7) sets at about 5.30 am and lies at the boundary between Aries and Taurus.

• At a brilliant magnitude –2.8, **Jupiter** is visible all night long in Taurus. The giant planet is closest to Earth on 6 December (see Special Events) and on 7 December is opposite the Sun. The Full Moon is near Jupiter on 14 December. With binoculars or a telescope, watch the orbital antics of its four biggest moons (see Objects).

• **Mars,** in Cancer, doubles in brightness during December, from magnitude –0.5 to –1.2, and rises around 7 pm. The Moon encroaches on the Red Planet on the night of 17/18 December, and occults Mars in the daytime sky between 9.26 and 10.17 am.

• During the second half of December, scan the south-eastern sky before dawn to spot **Mercury.** At its greatest separation from the Sun on 25 December, the innermost planet is rising at 6.15 am and shines at magnitude –0.3. The Moon is nearby on 28 December (Chart 12b).

Can you see the planets? It's a common question; and the answer is a resounding 'yes!' Some of our cosmic neighbours are the brightest objects in the night sky after the Moon. As they're so close, you can watch them getting up to their antics from night to night. And planetary debris – leftovers from the birth of the Solar System – can light up our skies as glowing comets and the celestial fireworks of a meteor shower.

THE SUN-HUGGERS

Mercury and Venus orbit the Sun more closely than our own planet, so they never seem to stray far from our local star: you can spot them in the west after sunset, or the east before dawn, but never all night long. At *elongation*, the planet is at its greatest separation from the Sun, though – as you can see in the diagram (right) – that's not when the planet is at its brightest. Through a telescope, Mercury and Venus (technically known as the *inferior planets*) show phases like the Moon – from a thin crescent to a full globe – as they orbit the Sun.

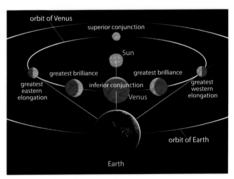

Venus (and Mercury) show phases like the Moon as they orbit the Sun.

Mercury

Mercury puts on its best evening performance in the latter half of March; it's visible low down in June–July; but it is lost in the evening twilight at its November elongation. There's better news for

Maximum elongations of Mercury in 2024	
Date	Separation
12 January	23° west
24 March	19° east
9 May	26° west
22 July	27° east
5 September	18° west
16 November	22° east
25 December	22° west

early risers: you can spot Mercury in the morning sky in January, September and December (though dawn light drowns out the planet at its May elongation).

Venus

You'll see Venus as the Morning Star in January and early February but it then sinks into the Sun's glow for six months, reappearing low in the dusk twilight as the Evening Star in August. Venus remains near the horizon until November, when it shoots upwards to end the year blazing in a dark sky. The planet does not reach maximum elongation from the Sun in 2024.

WORLDS BEYOND

A planet orbiting the Sun beyond the Earth (known in the jargon as a *superior*

planet) is visible at all times of night, as we look outwards into the Solar System. It lies due south at midnight when the Sun, the Earth and the planet are all in line – a time known as *opposition* (see the diagram, right). Around this time the Earth lies nearest to the planet, although the date of closest approach (and the planet's maximum brightness) may differ by a few days because the planets' orbits are not circular.

Mars

The Red Planet is lost in the morning twilight until May. It then brightens continuously as Mars heads towards opposition in January 2025. The planet has a close encounter with Jupiter on **15 August**, and during the latter months of 2024 is prominent in the evening sky.

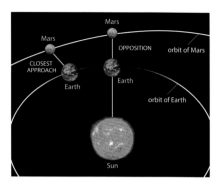

Mars (and the outer planets) line up with the Sun and Earth at opposition, but they are brightest at their point of closest approach.

● Where to find Mars	
May–early June	Pisces
Mid-June–mid-July	Aries
Late July–August	Taurus
September–October	Gemini
November–December	Cancer

Jupiter

The giant planet is brilliant in the evening sky until the end of April, lying in Aries. Jupiter reappears before dawn in mid-June, moving into Taurus where it remains for the rest of the year. The planet is closest to the Earth on **6 December**, and reaches opposition on **7 December**.

Saturn

The ringed planet lies in Aquarius all year. In January and early February you can catch Saturn in the west after sunset. It then disappears behind the Sun and reappears in the morning sky in May.

There's a rare chance to see the Moon occult Saturn on **21 August**. On **8 September**, Saturn is at opposition and at its closest to the Earth.

Uranus

Up until April, the seventh planet is visible in the evening sky: the planet re-emerges in the morning sky in July, and reaches opposition on **17 November**. Uranus lies in Aries throughout 2024.

Neptune

The most distant planet – in Pisces all year – reaches opposition on **20 September**. Neptune can be seen (though only through binoculars or a telescope) in January and February and then from June until the end of the year.

SOLAR ECLIPSES

On **8 April**, a total eclipse of the Sun is visible from a narrow track across North America, from Mexico through the USA to Quebec in Canada. A partial eclipse will be seen from most regions of North and Central America; and also from Ireland and western Scotland at sunset.

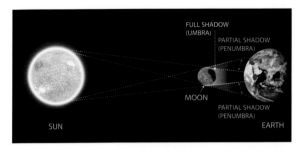

Where the dark central part (the umbra) of the Moon's shadow reaches the Earth, we are treated to a total solar eclipse. If the shadow doesn't quite reach the ground, we see an annular eclipse. People located within the penumbra observe a partial eclipse.

The track of an annular eclipse of the Sun on **2 October** passes over the southern Pacific Ocean, making landfall at Rapa Nui (Easter Island) and the southernmost tip of South America. It's visible as a partial eclipse from much of South America. Nothing is visible from the UK or Ireland.

LUNAR ECLIPSES

On the morning of **25 March**, the Moon is slightly dimmed by the outer part of the Earth's shadow in a penumbral eclipse, but it sets during the eclipse as seen from Britain and Ireland.

A partial lunar eclipse is visible from Europe, Africa and the Americas on **18 September**, but only 8 per cent of the Moon is obscured by the Earth's shadow at maximum eclipse.

METEOR SHOWERS

Shooting stars, or *meteors,* are tiny specks of interplanetary dust burning up in the Earth's atmosphere. At certain times of year, Earth passes through a stream of debris (usually left by a comet) and we see a *meteor shower.* The meteors appear to emanate from a point in the sky known as the *radiant.* Most showers are known by the constellation in which the radiant lies.

It's fun and rewarding to hold a meteor party. Note the location, cloud cover, the time and brightness of each meteor and its direction through the stars – along with any persistent afterglow (train).

Table of annual meteor showers	
Meteor shower	Date of maximum
Quadrantids	3/4 January
Lyrids	22/23 April
Eta Aquarids	6 May (am)
Perseids	12/13 August
Orionids	21/22 October
Leonids	17/18 November
Geminids	14/15 December

COMETS

Comets are dirty snowballs from the outer Solar System. If they fall towards the Sun, its heat evaporates their ices to produce a gaseous head (*coma*) and sometimes dramatic tails. Although some comets are visible to the naked eye, use binoculars to reveal stunning details in the coma and the tail.

Hundreds of comets move round the Sun in small orbits. But many more don't return for thousands or even millions of years. Most comets are now discovered in professional surveys of the sky, but a few are still found by dedicated amateur astronomers.

Comet Pons-Brooks should just reach naked-eye visibility in March–April, and will be an easy sight in binoculars: also watch out for sudden flare-ups that could make it a prominent sky sight.

In September to October, Comet Tsuchinshan-ATLAS will be visible to the unaided eye: there's a chance it will be spectacular after rounding the Sun.

Here are some of the most popular sights in the night sky, in a season-by-season summary. It doesn't matter if you're a complete beginner, finding your way around the heavens with the unaided eye ◉ or binoculars ♫; or if you're a seasoned stargazer, with a moderate telescope ⋋. There's something here for everyone.

Each sky sight comes with a brief description, and a guide as to how you can best see it. Many of the most delectable objects are faint, so avoid moonlight when you go out spotting. Most of all, enjoy!

SPRING

Praesepe

Constellation: Cancer
Star Chart/Key: March; **5**
Type/Distance: Star cluster; 600 light years
Magnitude: +3.7
A fuzzy patch to the unaided eye; a telescope reveals many of its 1000 stars.

M81 and M82 ♫ ⋋

Constellation: Ursa Major
Star Chart/Key: March; **6**
Type/Distance: Galaxies; 12 million light years
Magnitude: +6.9 (M81); +8.4 (M82)
A pair of interacting galaxies: the spiral M81 appears as an oval blur, and the starburst M82 as a streak of light.

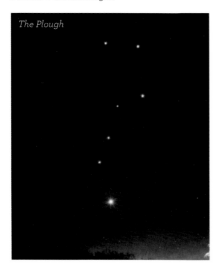
The Plough

The Plough ◉

Constellation: Ursa Major
Star Chart/Key: April; **7**
Type/Distance: Asterism; 82–123 light years
Magnitude: Stars are roughly magnitude +2
The seven brightest stars of the Great Bear form a large saucepan shape, called 'the Plough'.

Mizar and Alcor

Constellation: Ursa Major
Star Chart/Key: April; **8**
Type/Distance: Double star; 83 & 82 light years
Magnitude: +2.3 (Mizar); +4.0 (Alcor)
The sky's classic double star, easily separated by the unaided eye: a telescope reveals Mizar itself is a close double.

Virgo Cluster ♫ (difficult) ⋋

Constellation: Virgo
Star Chart/Key: May; **9**
Type/Distance: Galaxy cluster; 54 million light years
Magnitude: Galaxies range from magnitude +9.4 downwards
Huge cluster of 2000 galaxies, best seen through moderate to large telescopes.

SUMMER

Antares

Constellation: Scorpius
Star Chart/Key: June; **10**
Type/Distance: Red giant; 550 light years
Magnitude: +0.96
Bright red star close to the horizon. You can spot a faint green companion with a telescope.

M13

Constellation: Hercules
Star Chart/Key: June;
Type/Distance: Star cluster; 23,000 light years
Magnitude: +5.8
A faint blur to the naked eye, this ancient globular cluster is a delight seen through binoculars or a telescope. It boasts nearly a million stars.

Lagoon and Trifid Nebulae

Constellation: Sagittarius
Star Chart/Key: July;
Type/Distance: Nebulae; 5000 light years
Magnitude: +6.0 (Lagoon); +7.0 (Trifid)
While the Lagoon Nebula is just visible to the unaided eye, you'll need binoculars or a telescope to spot the Trifid. The two are in the same binocular field of view, and present a stunning photo opportunity.

Albireo

Constellation: Cygnus
Star Chart/Key: August;
Type/Distance: Double star; 430 light years
Magnitude: +3.2 (Albireo A) ; +5.1 (Albireo B)
Good binoculars reveal Albireo as being double. But you'll need a small telescope to appreciate its full glory. The brighter star appears golden; its companion shines piercing sapphire. It is the most beautiful double star in the sky.

Dumbbell Nebula

Constellation: Vulpecula
Star Chart/Key: August;
Type/Distance: Planetary nebula; 1270 light years
Magnitude: +7.5

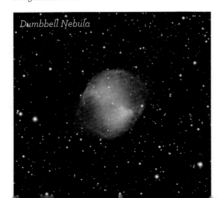
Dumbbell Nebula

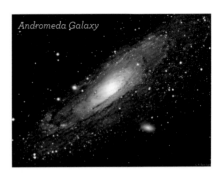
Andromeda Galaxy

Visible through binoculars, and a lovely sight through a small/medium telescope, this is a dying star that has puffed off its atmosphere into space.

AUTUMN

Delta Cephei

Constellation: Cepheus
Star Chart/Key: September;
Type/Distance: Variable star; 890 light years
Magnitude: +3.5 to +4.4, varying over 5 days 9 hours
The classic variable star, Delta Cephei is chief of the Cepheids – stars that allow us to measure distances in the Universe (their variability time is coupled to their intrinsic luminosity). Visible to the unaided eye, but you'll need binoculars for serious observations.

Andromeda Galaxy

Constellation: Andromeda
Star Chart/Key: October;
Type/Distance: Galaxy; 2.5 million light years
Magnitude: +3.4
The nearest major galaxy to our own, the Andromeda Galaxy is easily visible to the unaided eye in unpolluted skies. Four times the width of the Full Moon, it's a great telescopic object and photographic target.

Mira

Constellation: Cetus
Star Chart/Key: November;
Type/Distance: Variable star; 300 light years
Magnitude: +2 to +10 over 332 days, although maxima and minima may vary.

Nicknamed 'the Wonderful', this distended red giant star is alarmingly variable as it swells and shrinks. At its brightest, Mira is a naked-eye object; binoculars may catch it at minimum; but you need a telescope to monitor this star. Its behaviour is unpredictable, and it's important to keep logging it.

Double Cluster
Constellation: Perseus
Star Chart/Key: November; **18**
Type/Distance: Star clusters; 7500 light years
Magnitude: +3.7 and +3.8
A lovely sight to the unaided eye, these stunning young star clusters are sensational through binoculars or a small telescope. They're a great photographic target.

Algol
Constellation: Perseus
Star Chart/Key: November; **19**
Type/Distance: Variable star; 90 light years
Magnitude: +2.1 to +3.4 over 2 days 21 hours
Like Mira, Algol is a variable star, but not an intrinsic one. It's an 'eclipsing binary' – its brightness falls when a fainter companion star periodically passes in front of the main star. It's easily monitored by the eye, binoculars or a telescope.

WINTER
Pleiades
Constellation: Taurus
Star Chart/Key: December; **20**
Type/Distance: Star cluster; 440 light years
Magnitude: Stars range from magnitude +2.9 downwards
To the naked eye, most people can see six stars in the cluster, but it can rise to 14 for the keen-sighted. In binoculars or a telescope, they are a must-see. Astronomers have observed 1000 stars in the Pleiades.

Orion Nebula
Constellation: Orion
Star Chart/Key: January; **1**
Type/Distance: Nebula; 1340 light years
Magnitude: +4.0

A striking sight even to the unaided eye, the Orion Nebula – a star-forming region 24 light years across – hangs just below Orion's belt. Through binoculars or a small telescope, it is staggering. A photographic must!

Betelgeuse
Constellation: Orion
Star Chart/Key: January; **2**
Type/Distance: Variable star; 720 light years
Magnitude: 0.0 to +1.6
Even with the unaided eye, you can see that Betelgeuse is slightly variable over months, as the red giant star billows in and out.

M35
Constellation: Gemini
Star Chart/Key: February; **3**
Type/Distance: Star cluster; 2800 light years
Magnitude: +5.3
Just visible to the unaided eye, this cluster of around 2000 stars is a lovely sight through a small telescope.

Sirius
Constellation: Canis Major
Star Chart/Key: February; **4**
Type/Distance: Double star; 8.6 light years
Magnitude: –1.47
You can't miss the Dog Star. It's the brightest star in the sky! But you'll need a 150-mm reflecting telescope (preferably bigger) to pick out its +8.44 magnitude companion – a white dwarf nicknamed 'the Pup'.

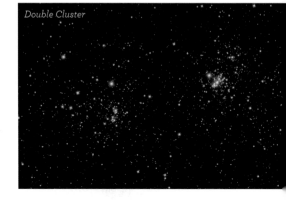
Double Cluster

BY ROBIN SCAGELL

How amateur astronomers have wished for a magic filter that can banish light pollution! Imagine holding it up to the suburban sky and seeing the heavens as if you were far from the city lights. Sadly, no such thing is likely to be possible, certainly not from the point of view of the visual observer. It's true that there are some filters that help to reduce the effects of light pollution for visual observers, but the results are not dramatic and they are mostly only useful in conjunction with fairly large telescopes and on a limited range of celestial objects.

However, suitably equipped amateur astronomers are now able to take spectacular images of a range of objects despite living in urban areas. This is possible due to the development of narrowband filters.

To understand how they work and their limitations you need to know something about the way astronomical objects shine. A typical star (the Sun being an example) shines with all the colours of the rainbow, quite literally. Put these colours together and you get white light. Raindrops, or prisms, spread them out

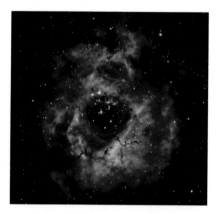

Kevin Earp took this image of the Rosette Nebula in Monoceros using a 100-mm refractor from Willington on the outskirts of Bedford using a ZWO ASI294MC colour camera and Optolong L-eNhance filter. The total exposure time was 4 hours.

again into their component colours. But the white LED lamps that are widely used these days in streetlights also have the same range of colours as starlight, so a night sky illuminated by LED lights can't be filtered in any way to allow the stars, the Milky Way or indeed distant galaxies to shine through.

However, some objects in the sky, generally known as nebulae (Latin for clouds), have a different distribution of light. They shine with very specific colours, or wavelengths of light, depending on the gas within them. Certain gases, notably hydrogen, oxygen and nitrogen, glow strongly with these colours. When the light from a nebula is spread out into its individual colours in a spectrum, instead of the full rainbow of colours as in white light, there are only specific colours, which appear as lines in the spectrum, known as emission lines. The great thing is that they are so specific that filters can be used that transmit only those wavelengths and reject all the others, including most of the light pollution even from sources of white light.

Visual observers have been using them for years, notably a filter that isolates only the light from triply ionised oxygen, known as an OIII (O-three) filter. Oxygen shines with two very close

THE NARROWBAND REVOLUTION

green lines, at wavelengths of 495.9 nanometres (nm) and 500.7 nm. So a filter with a bandwidth of about 12 nm will transmit nearly 100 per cent of the light from these lines. Fortunately the human eye is very sensitive to green light, so an OIII filter used on a fairly large telescope will allow some nebulae to be seen that would otherwise be hidden by the light pollution. For visual use a wide bandpass permits more light to reach the eye so as to give the best chance of seeing the nebula.

The most common nebula lines in the visible part of the spectrum are the deep red hydrogen alpha line at 656.3 nm, the two green OIII lines already mentioned at around 500 nm and the turquoise hydrogen beta line at 486.1 nm. In addition there are sulphur lines in the extremely deep red at 671.6 nm and nitrogen lines at 654 and 658 nm. The deep red lines are right at the edge of human colour sensitivity, so filters that transmit these are of no help to visual observers.

But the sensor of a camera can build up light during exposure times of minutes to reveal objects much fainter than the eye can see. It is possible to make filters that isolate the light from the nebula even more precisely than with visual filters, typically 6 nm or 3 nm, so as to exclude even more light pollution. The darker image can be compensated for by increasing the exposure time. This is where the magic has allowed the camera to seemingly beat the light pollution, even in city skies. The recent development of dual-band filters has opened up the field even to those using everyday DSLR (digital single-lens reflex) cameras rather than the more specialised astro-cameras.

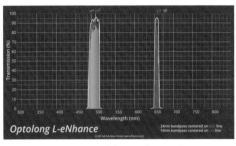

The transmission curve of the popular Optolong L-eNhance dual-band filter. The curve shows how it transmits the blue and green lines from hydrogen beta and oxygen, and the red line from hydrogen alpha.

Normal colour images, in both cameras and the eye, are created by combining red, green and blue images into a single view. So although nebulae don't have well-spaced red, green and blue emission lines it is possible to produce effective colour images by using separate narrowband filters and combining the results, with colourful nebulae and white stars. Because the background light, and even white light from moonlight, is much fainter than the light from the object, nebulae can be photographed even from light-polluted city sites where the objects themselves are totally invisible. And in the UK few sites are free from the effects of light pollution, so even from country areas the filters make a huge difference.

WHAT CAN BE PHOTOGRAPHED

Types of nebula include clouds of gas lit up by recently born stars, supernova remnants that are the remains of massive stars that have exploded as supernovae, and so-called planetary nebulae that are shells of gas thrown off from stars at the end of their lives. Such objects are mostly found along the line of the Milky Way.

Typically the first two types are large in the sky, some being the size of the Full Moon or larger, while planetary nebulae are small, about the size of planets (hence their name). In all cases telescopes are needed to obtain reasonably sized images, although for the larger objects even a small instrument is more than adequate.

However, because of the narrow band-pass of the filters long exposure times are needed, often several hours for the best results. The telescope must be on a stable equatorial-type mounting that accurately tracks the stars, usually with an autoguider to overcome any slight errors in the tracking rate or alignment. Such equipment can be assembled for several hundred pounds, but the setting-up time and the expertise required are more than the simple point-and-shoot that you can get away with for photographing the Moon, say.

CAMERAS AND FILTERS

There is now a bewildering choice of filters depending on the nebula lines that are transmitted, the narrowness of the bandwidth and the size of the filter, from several different manufacturers. The prices range from under £100 for a small filter with a wide bandwidth, up to over £1500 for a large narrowband filter. Most people will need to be careful over their decision, depending on their camera and which type of object they plan to aim for.

Many astrophotographers use standard DSLR or mirrorless cameras, which can be attached to a telescope in place of the lens by using an adapter for the particular lens mount. These have the advantage of being available for everyday photography as well. The filter may be placed within a specially designed adapter, in which case a 2-inch filter is required. Alternatively, many filters are available as clip filters, which are placed temporarily within the camera body itself.

The alternative is to use a specialised astro-camera. These are priced from under £200 for a basic model with a small sensor and no cooling up to thousands for units with large, state-of-the-art sensors

At left, the result of a 3-minute exposure using a Canon 90D DSLR of the region below the lower two stars of Orion's Belt by Andy Smith from his site near Bicester in Oxfordshire. The local light pollution wipes out all but the brighter stars. At right, using a dual-band Optolong L-eNhance clip filter in the camera with the same exposure time reveals the Flame Nebula and the Horsehead Nebula.

Rachael Wood's photo of the Wizard Nebula, NGC 7380, in Cepheus, was taken from Doncaster with a total exposure time of 4 hours, using 5-minute sub-exposures. She and husband Jonathan used a ZWO ASI294MC colour astro-camera with Optolong L-eNhance filter which suppressed the light pollution to give a black sky background. They created the Hubble Palette appearance in Photoshop by making the OIII part of the image blue and creating a green channel by blending the red and blue channels.

and cooling to reduce the effects of electronic noise during long exposures. In general, expect to pay £1000 or more for an electronically cooled camera with good performance. Cameras may be either mono or colour, usually for similar prices.

With a mono camera you can take separate images using hydrogen alpha and OIII filters, and possibly a hydrogen beta or sulphur SII (S-two) filter as well. Combining the results using photo-processing software can give a variety of results, including what is called the Hubble Palette, first used on images from the Hubble Space Telescope. Where only two filters are used, people can create either a combined red–blue image in place of green, or use the blue image for both blue and green channels. Several of the images in this volume were taken in this way, such as those from the UK on pages 59 and 77.

For those with colour cameras, whether DSLRs or astro-cameras, a notable advance in recent years has been the introduction of dual- or tri-band filters. In this case, a single filter transmits red hydrogen alpha, green OIII and blue–green hydrogen beta. So a single exposure yields a colour image, which can then be processed to achieve a variety of results, including even a Hubble Palette appearance, by separating out the red, green and blue channels in a photo-processing package such as Photoshop or the much cheaper Affinity software, and assigning different colours to the individual channels.

While narrowband filters can achieve amazing results even from severely light-polluted sites, they can only do so for nebulae, and even then some nebulae are more suitable than others. What they can't do is to make the light pollution disappear when photographing galaxies and star clusters, where the stars are essentially the same colour as the light pollution. But within these limitations, you can create magic!

Narrowband photography does not require large instruments. Rachael Wood uses an 80-mm Sky-Watcher refractor from light-polluted Doncaster. The smaller telescope on the top has a small camera attached to maintain perfect guiding of the main instrument.

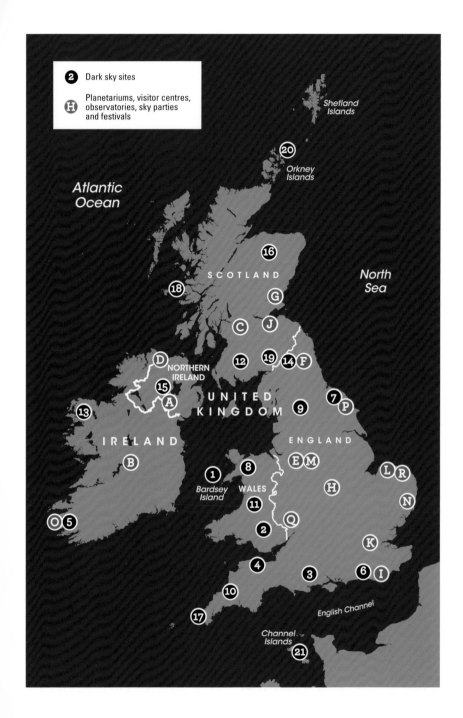

ASTRO PLACES & EVENTS

Take a break from your backyard astronomy, and head off to view the stunning skies from a protected dark-sky site. Or visit a major observatory or planetarium. Even more fun, take part in a major star party or astronomical festival.

DARK-SKY SITES

The International Dark-Sky Association, based in Tucson, Arizona, checks out the darkest places in the world. In these islands, 21 places are internationally recognised for their unsullied view of the heavens or their commitment to combating light pollution. Many are in Areas of Outstanding Natural Beauty (AONB).

DARK SKY SANTUARY

Noted for exceptionally dark nights and a nocturnal environment protected for its scientific and cultural heritage, a Dark Sky Sanctuary is often in a remote location.

1. Bardsey Island

Designated: 2023 • *Area:* 1.8 sq km
Nearest town: Pwllheli • *Website:* https://www.bardsey.org/darkskysanctuary
Europe's first designated Dark Sky Sanctuary is home to a major bird observatory, with an emphasis on nocturnal species. It lies 3 kilometres off the Welsh coast, and is accessible only by small boat during good weather.

DARK SKY RESERVES

Dark Sky Reserves are generally large, and consist of a very dark core region surrounded by a peripheral area where lighting is minimal. Eight out of a total of 19 worldwide are in Britain and Ireland:

2. Brecon Beacons National Park

Designated: 2013 • *Area:* 1347 sq km
Nearest towns: Brecon, Merthyr Tydfil
Website: https://www.breconbeaconsparksociety.org/
Situated in the mountains of South Wales, where sheep outnumber humans 30 to 1, this Reserve is home to 33,000 people – yet lighting is controlled so that the core zone has some of the darkest skies in Wales.

3. Cranborne Chase

Designated: 2019 • *Area:* 981 sq km
Nearest towns: Salisbury, Shaftesbury
Website: https://cranbornechase.org.uk/
Not far from Stonehenge, Cranborne Chase is a chalk plateau rising to 277 m at Win Green. This AONB has commanding views to the west and to some extent to the north.

4. Exmoor National Park

Designated: 2011 • *Area:* 693 sq km
Nearest towns: Barnstaple, Minehead, Taunton
Website: https://www.exmoor-nationalpark.gov.uk/enjoying/stargazing
The first Dark Sky Reserve site to be designated in these islands, Exmoor is a moorland area with much preserved history and many monuments within the 81-sq-km core zone.

5. Kerry

Designated: 2014 • *Area:* 700 sq km
Nearest towns: Kenmare, Waterville
Website: https://www.kerrydarkskytourism.com/
Its location between the Kerry Mountains and the Atlantic Ocean gives this Dark Sky Reserve natural protection from light pollution, yet it's readily accessible from the Wild Atlantic Way, the stunning tourist route that runs through the reserve.

6. Moore's Reserve (South Downs)

Designated: 2016 • *Area:* 1627 sq km
Nearest towns: Brighton, Portsmouth
Website: https://www.southdowns.gov.uk/
Named after the British astronomy populariser Sir Patrick Moore (1923–2012) who lived

nearby, this reserve is sandwiched between London and the busy seaside resorts of Brighton and Worthing – yet it retains remarkably dark skies.

7. North York Moors National Park

Designated: 2020 • *Area:* 1440 sq km
Nearest towns: Scarborough, Whitby
Website: https://www.northyorkmoors.org.uk/
Despite its proximity to the busy tourist destinations of Whitby and Scarborough, the North York Moors is a largely deserted expanse of heather and bog moorland, with wide views of the night sky.

8. Snowdonia National Park

Designated: 2015 • *Area:* 2132 sq km
Nearest towns: Harlech, Porthmadog
Website: https://www.snowdonia.gov.wales/home
The national park encompasses around 10 per cent of the total land area of Wales, and the darkest skies are to be seen from the rugged central area around Mount Snowdon (1085 m).

9. Yorkshire Dales National Park

Designated: 2020 • *Area:* 2180 sq km
Nearest towns: Hawes, Kirby Lonsdale
Website: https://www.yorkshiredales.org.uk/
The largest dark-sky site in Britain and Ireland, the Yorkshire Dales National Park boasts impressive waterfalls and caves, and brilliant night skies within reach of major cities like Leeds and Manchester.

DARK SKY PARKS

Smaller regions with exceptionally low light pollution are designated Dark Sky Parks. Currently numbering eight in Britain and Ireland, more are being added every year.

10. Bodmin Moor Dark Sky Landscape

Designated: 2017 • *Area:* 208 sq km
Nearest towns: Bodmin, Launceston, Liskeard
Website: https://www.cornwall-aonb.gov.uk/bodminmoor/

Galloway Forest Park

This remote, rugged area of granite moorland in north-east Cornwall is a working agricultural landscape, protecting it from large-scale development that would threaten dark skies.

11. Elan Valley Estate

Designated: 2015 • *Area:* 180 sq km
Nearest towns: Aberystwyth, Rhayader
Website: https://www.elanvalley.org.uk/
The city of Birmingham purchased this Welsh valley in 1892 to construct reservoirs that would provide a regular supply of pure water. Views of the starry night over the reservoirs are particularly impressive.

12. Galloway Forest Park

Designated: 2009 • *Area:* 780 sq km
Nearest towns: Girvan, Newton Stewart
Website: https://www.forestryandland.gov.scot/visit/forest-parks/galloway-forest-park/dark-skies
Galloway Forest Park is the largest forest park in the UK, and 20 per cent has been set aside as a core area with no illumination allowed. It's a mecca not just for astronomers but for nocturnal wildlife whose lives are often disrupted elsewhere by light pollution.

13. Mayo Dark Sky Park

Designated: 2016 • *Area:* 150 sq km
Nearest towns: Ballina, Castlebar
Website: https://www.mayodarkskypark.ie/
One of the largest expanses of peat landscape in Europe, this region supports a unique diversity of bog-dwelling species. Unsuitable for agriculture, and adjoining the Atlantic Ocean, the park should enjoy pristine skies far into the future.

14. Northumberland National Park and Kielder Water & Forest Park

Designated: 2013 • *Area:* 1592 sq km
Nearest towns: Jedburgh, Rothbury
Websites: https://www.northumberlandnation
alpark.org.uk/; http://www.visitkielder.com/
Near Hadrian's Wall, built to keep the Picts
from Roman Britain, this Dark Sky Park was
designated as a bulwark against light pollu-
tion invading the darkness of northern Eng-
land. It contains the largest reservoir and
most extensive forest in northern Europe.

15. OM Dark Sky Park & Observatory

Designated: 2020 • *Area:* 15 sq km
Nearest towns: Cookstown, Magherafelt
Website: https://www.midulstercouncil.org/
davaghforest
The first dark-sky place accredited in North-
ern Ireland, OM is set among rolling hills
and is centred on the Bronze Age site of
Beaghmore Stone Circles.

16. Tomintoul and Glenlivet, Cairngorms

Designated: 2018 • *Area:* 230 sq km
Nearest towns: Dufftown, Grantown-on-Spey
Website: https://www.cairngormsdarksky-
park.org/
Containing the dramatic landscape of the
Cairngorm Mountains, this Dark Sky Park is
home to Britain's only herd of wild reindeer.
And, if the weather is cloudy, the Park also
contains the Glenlivet whisky distillery!

17. West Penwith

Designated: 2021 • *Area:* 136 sq km
Nearest towns: Penzance, St Ives
Website: https://www.cornwall-aonb.gov.uk/
westpenwith
The very western tip of Cornwall, stretch-
ing down to Land's End, West Penwith is
a wild landscape, with stunning sea views
and ancient archaeological remains – some
thought to be astronomically aligned.

DARK SKY COMMUNITIES

A town, village or complete island that's
actively fighting light pollution can be
designated a Dark Sky Community, with
three listed in Britain and Ireland so far,
plus one in the Channel Islands.

18. Coll

Designated: 2013 • *Area:* 77 sq km
Website: https://visitcoll.co.uk/dark_sky/
The Scottish island of Coll is home to just
200 permanent residents, plus a myriad of
birds in its extensive nature reserve. The
island has adopted a light-management plan
to ensure its skies remain dark.

19. Moffat

Designated: 2016 • *Area:* 147 sq km
Website: https://visitmoffat.co.uk/
This former spa town is a tourist base for south-
ern Scotland. It has strict outdoor lighting pol-
icies to reduce light pollution in its hinterland.

20. North Ronaldsay

Designated: 2021 • *Area:* 7 sq km
Website: https://www.northronaldsay.co.uk
The northernmost island in Orkney. Many
visitors come to its bird observatory, and the
island's appeal extends to astronomers with its
Dark Sky Community designation.

21. Sark

Designated: 2011 • *Area:* 5 sq km
Website: http://www.sark.co.uk/
One of the Channel Islands, Sark was Europe's
first Dark Sky Community. Its pitch-black skies
are largely due to the island's ban on public
lighting and motor vehicles apart from tractors.

Tomintoul and Glenlivet

PLANETARIUMS, VISITOR CENTRES AND OBSERVATORIES

For a great day out under the cloudless sky of a planetarium, a tour of a world-beating observatory or an evening observing the stars, here are some leading locations. Many venues combine a planetarium (⬤), visitor centre (Ⓥ) and observatory (⬤).

A. Armagh Observatory and Planetarium

Website: https://www.armagh.space/
Armagh has the longest-running planetarium and the second-oldest observatory in the UK. Combine a state-of-the-art digital planetarium show with a tour of the observatory's ancient instruments (book in advance for the latter).

B. Birr Castle Demesne Ⓥ

Website: https://birrcastle.com/
Marvel at the well-preserved remains of the Leviathan of Parsonstown, the largest telescope in the world from 1845 to 1917. The Science Centre chronicles how the Third Earl of Rosse created his great instrument, and discovered the spiral shape of galaxies.

C. Glasgow Science Centre Planetarium ⬤

Website: https://www.glasgowsciencecentre. org/discover/our-experiences/planetarium
One of Scotland's most popular visitor attractions, Glasgow Science Centre features a 15-m diameter planetarium. After viewing the night sky in comfort, you can be awed by the giant screen of the Centre's IMAX cinema.

D. Inishowen Planetarium ⬤

Website: https://inishowenmaritime.com/planetarium/
Part of the Inishowen Maritime Museum, the planetarium is picturesquely set beside Lough Foyle. As well as putting on astronomy shows, the Maritime Museum uses the planetarium dome to project immersive ocean experiences.

E. Jodrell Bank Discovery Centre

Website: https://www.jodrellbank.net/
Grab a close-up view of the Lovell Telescope, the great radio dish that tracked rockets in the early days of the space race, downloaded pictures from the Moon and now investigates the secrets of pulsars. Other displays include exhibitions, talks and interactive activities.

F. Kielder Observatory ⬤

Website: https://kielderobservatory.org/
The Kielder Observatory, sited under some of the darkest skies in England, has a variety of telescopes for visual observing and astrophotography. It hosts some 700 events per year.

G. Mills Observatory ⬤ ⬤

Website: http://www.leisureandculturedundee. com/culture/mills
On a hill above Dundee, the Mills Observatory was the UK's first purpose-built public observatory, and it carries on opening its doors to the public every clear weeknight. There's also a small planetarium and a gift shop.

H. National Space Centre ⬤ Ⓥ

Website: https://spacecentre.co.uk/
Located on the outskirts of Leicester, this visitor centre focuses on the history – and future – of the UK in space exploration. Explore the wider Universe in the 192-seat Sir Patrick Moore planetarium.

I. Observatory Science Centre Ⓥ ⬤

Website: https://www.the-observatory.org/
On a hillside at Herstmonceux in Sussex, the Observatory Science Centre is located within a cluster of green domes that once housed the telescopes of the Royal Greenwich Observatory. As well as fascinating exhibits, the observatory holds regular stargazing evenings.

J. Royal Observatory, Edinburgh Ⓥ ⬤

Website: https://visit.roe.ac.uk/
Scotland's premier observatory no longer makes professional observations: its astronomers now build and use large telescopes on Hawaii and in Chile. But the Edinburgh site is

still active, with a visitor centre, regular astronomical talks and public stargazing evenings.

K. Royal Observatory and Peter Harrison Planetarium

Websites: https://www.rmg.co.uk/royal-observatory; https://www.rmg.co.uk/whats-on/planetarium-shows
The home of British astronomy, the Royal Observatory at Greenwich is a fascinating museum of astronomy and timekeeping: stand on the Meridian Line, with a foot in each hemisphere! The planetarium hosts a variety of astronomical shows.

STAR PARTIES AND FESTIVALS

Enjoy an astronomical weekend or a festival with music – there's something for everyone at these annual events.

L. Autumn Equinox Sky Camp

Kelling Heath, Norfolk • September
Website: https://las-skycamp.org/
Claiming to be the largest star party in the UK, the Autumn Equinox Sky Camp fills three fields with astronomers, tents, trade stands and some of the top-end amateur telescopes.

M. Bluedot Festival

Jodrell Bank, Cheshire • July
Website: https://www.discoverthebluedot.com/
Astronomy's answer to Glastonbury, with live music, illuminated artworks, astronomy- and science-themed tents, cosmic inflated domes, family fun and talks from leading astronomers. Too busy and bright to actually observe the sky.

Bluedot Festival

N. Haw Wood

Saxmundham, Suffolk • April
Website: https://www.brecklandastro.org.uk/star-parties/
Astronomers literally pitch up at Haw Wood farm for a small-scale, friendly week of stargazing, organised by local astronomical societies.

O. Skellig Star Party

Ballinskelligs, County Kerry • August
Website: https://www.facebook.com/Skellig StarParty
Ireland's leading star party is held under the pristine skies of the Kerry Dark Sky Reserve. It features talks by leading astronomers as well as night-time observing.

P. StarFest

Dalby Forest, North Yorkshire • August
Website: http://www.scarborough-ryedale-as.org.uk/saras/starfest/about-starfest/
This event attracts astronomers from all over the country for a weekend of events that can include rocket-building, talks, an astronomical pub quiz and – of course! – observing the sky.

Q. Stargazers' Lounge Star Party

Lucksall Caravan and Camping Park, Herefordshire • October
Website: https://stargazerslounge.com/
Stargazers' Lounge is an online forum for amateur astronomers, but they meet in real life in Herefordshire for a weekend of talks, trade stands, socialising and skywatching.

R. WinterFest

Kelling Heath, Norfolk • December
Website: https://www.winterfestastro.co.uk/
Organised by the Birmingham Astronomical Society to give its members some respite from the city's lights, WinterFest is open to all who want to brave the December weather in pursuit of the glittering winter stars.

Many of the sites on pages 91–93 also host their own star parties or weekends: check their websites. Also see https://www.dark-skiesnationalparks.org.uk/ for events.

THE AUTHOR

Nigel Henbest is an award-winning British science writer, specialising in astronomy and space. After research in radio astronomy at Cambridge, he became a consultant to both the Royal Greenwich Observatory and *New Scientist* magazine, and is a Fellow of the Royal Astronomical Society.

Originally with Heather Couper, Nigel has been writing Philip's *Stargazing* since 2005. The author of 40 other books, Nigel is a regular media commentator on breaking astronomy news. He co-founded a TV production company, where he produced acclaimed programmes and international series on astronomy and space.

Nigel divides his time between Buckinghamshire and North Carolina. He is a Future Astronaut with Virgin Galactic, and asteroid 3795 is named 'Nigel' in his honour.

ACKNOWLEDGEMENTS

PHOTOGRAPHS

Front cover: Emma Rennie, https://callanish-digitaldesign.com
Aboyne Photographics/Alamy Stock Photo: 93; **Stuart Atkinson:** 41; **Nico Carver (Nebula Photos) (CC BY-SA 4.0):** 87 (hb line added); **Dr J M Dean FRAS:** 29; **Kevin Earp:** 86; **Shirlaine Forrest/WireImage/Getty Images:** 95; **Robert Gendler/NASA:** 84a; **Goddard/NASA:** 24; **Bridget Henbest:** 96; **Nigel Henbest:** 7; **Simon Hudson:** 1; **Imagine China/Alamy Stock Photo:** 12; **Peter Jenkins FRAS:** 59, **/Telescope Live:** 47; **JPL-Caltech/NASA:** 43; **JPL/NASA:** 37; **Pete Lawrence:** 11; **Keith Mason/Alamy Stock Photo:** 92; **David Moug via Wikimedia:** 42; **NASA:** 36; **Nielander via** **Wikimedia Commons (CC BY-SA 4.0):** 18; **Gary Palmer:** 23; **Damian Peach:** 35, 71; **Sean M Sabatini/NASA:** 72; **Robin Scagell:** 6, 84b; **Peter Shah:** 85; **Andy Smith:** 88l&r; **UCLA/NASA:** 2–3; **VegaStar Carpentier/NASA:** 83; **Denis Walsh:** 64; **Andrew Weller:** 77; **Pete Williamson FRAS:** 17, 52; **Jonathan and Rachael Wood:** 89a&b.

ARTWORKS

Star maps: Wil Tirion/Philip's with extra annotation by Philip's.
Planet event charts: Nigel Henbest/Stellarium (www.stellarium.org).
Pages 80–82: Chris Bell.
Page 90: Philip's